CREATIVE FASHION DESIGN
with Illustrator®

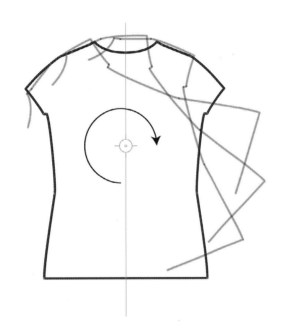

New edition

CREATIVE FASHION DESIGN

with Illustrator®

New edition

Kevin Tallon

BATSFORD

First published in the United Kingdom in 2013
by Batsford
10 Southcombe Street, London W14 0RA

An imprint of Anova Books Company Ltd

ISBN 978 1 84994 120 4

A CIP catalogue record for this book is available from the British
Library.

10 9 8 7 6 5 4 3 2 1

Reproduction by Rival Colour Ltd, UK
Printed and bound by 1010 Printing International Ltd, China

This book can be ordered direct from
the publisher at www.anovabooks.com.

Contents

Preface

Since the first edition of *Creative Fashion Design with Illustrator*® back in 2006 (which was my first ever book to be published), I have written and published two other titles on the topic of digital creativity in a fashion context – *Digital Fashion Illustration* (2008) and *Digital Fashion Print* (2011). This new version of *Creative Fashion Design with Illustrator* is the culmination of nearly two decades of work with Illustrator in a fashion context, and my core teaching methodology has evolved with each book. Over the years, two simple principles remain, namely learn only what you need to and never sacrifice creativity when using technology. Always view technology as a tool, like a pen, that you can use to express your creativity; learning a skill is simply a step towards achieving your creative goal.

With those two principles firmly in mind, I have striven to deliver the perfect textbook for learning Adobe Illustrator and Photoshop in a fashion context. My mission was not a solitary one – indeed I have benefited from much priceless feedback from students during courses and workshops, where they showed me their own take on certain skills and creative paths. My publisher has also helped me a great deal with insightful feedback from readers on the content and format that they have found to be the most helpful.

Illustrator has evolved since 2006 and has a raft of new features. Yet at its core, the same principles apply, and some of the old wisdom is still relevant. This book takes the best of the features and techniques from past years and adds the latest ones. I am not precious about holding on to carefully nurtured skills if new features allow me to do something better and faster. However, old ways undefeated by snazzy new features remain in my teaching methodology.

This new edition also redefines the way in which the content is presented to the reader. One chapter is dedicated to novice users, but the main content is firmly targeted at what I consider to be the norm today: computer-literate users who can pick up new skills fast. I am still amazed at how many designers in the professional world use Illustrator the wrong way, one of the pitfalls of this know-it-all, learn-fast generation. When people are used to learning everything intuitively (a throw-the-manual-in-the-bin sort of approach), it is actually quite hard to convince them to take time to read and learn new skills! With this in mind, I have tried to slim down the text and give as many examples as possible for those who want to learn a skill for a specific problem.

All in all, this new edition is a complete overhaul of the first one, encompassing over ten years' experience of teaching students and professional fashion designers how to use Illustrator's many complicated features. I prefer to suggest and guide while allowing as much space as possible for creativity and exploration.

Kevin Tallon

Introduction

The changing face of fashion design

Essentially, we fashion designers are doing the same work as our predecessors during the past hundred years, namely creating clothes – from sketching an idea to making a finished and hopefully wearable product. However, the process has changed dramatically – to a complex and highly efficient system that can create, manufacture and deliver apparel to the masses in shorter-than-ever lead times. As we have become more efficient at delivering fashion products to the stores, so the consumer's appetite for ever-changing fashion has become more voracious.

Fast fashion and über-luxury

Undoubtedly the fast-fashion and quick-response business models, both within the High Street and other fashion sectors, have influenced the first decade of the 21st century. The demands of fast fashion have not only resulted in a race between High Street competitors, trying to 'out-time' each other: fast fashion has also forced other business models to be reconsidered, transformed and remodelled in order to adapt and survive. The luxury sector, for example, has been quick to offer a credible alternative by marketing the idea that slow is good, that ultimate quality can only be attained with time and attention to detail, just like an exceptional wine needs time to mature to reach its peak. When Tom Ford launched his first ever womenswear collection without allowing any photographers at the show (effectively starving the fast fashion behemoth of its prime foodstuff), it created an instant sensation. He was basically saying that good things come to those who wait.

The 21st century has also witnessed an undoubtedly brazen move towards über-luxury, with outrageous price tags and ostentatious products. The fashion landscape resembles a valley with two banks: one side is littered with words such as 'instant satisfaction', 'availability before quality' and 'throw-away fashion', while the other contains gems such as 'über-luxury', 'rare', 'limited edition', and 'made to order'. Companies have either lifted themselves to lofty heights of luxury by trading with their brand equity, or are battling it out in the unforgiving world of fast fashion. The middle ground is strewn with companies that do not have the resources to change their business model to faster or better products, and are limping on.

Fashion consumption

People need clothes and clothes need people, and both have evolved over time. After the Second World War, clothing was still rationed. Most had to make do with a Sunday suit and little weekly variation. Clothes were built to last because they had to, and having a sewing machine at home was considered as vital as having a mobile phone is today.

As technology improved, brighter colours started to appear thanks to better dyestuffs, and in the 1950s, novel man-made fibres such as polyester began to be widely used. In fashion and product design, technology became much more prevalent and influential. Everything became more colourful, design-led and available.

As time went on, innovations in shapes, cuts, colours, surfaces and details caused the process of designing to be more conceptually led. Research into other cultures, history and fantasy broadened the landscape associated with fashion (for example Pierre Cardin's space odyssey-inspired collections). Design awareness started to become a part of self-identity. Brand awareness also grew, especially in the 1980s, when specific labels and brands embodied status and power. For designers, this required a gradual shift from knowing how to make a garment to knowing how to make a garment with a specific identity, function or theme.

As consumers started to consume more fashion, each piece of apparel became more specialized. Whereas during the post-war years one might have practised physical education in a vest or T-shirt that was merely underwear used for another function, a few decades later, a whole sportswear industry for the masses was thriving, with specifically designed sports apparel for new activities such as jogging, skateboarding and yoga. This expansion was seen in all areas of fashion, and so being a designer became a valid and more widely accepted career path.

The beginning of the 21st century has been a pivotal point in time for fashion. Although it is still too recent to really put the true impact of the era into context, we can safely assume that the main narrative is focused on fast fashion, a term coined around the business model developed by the Spanish retail group Inditex and mainly associated with Zara, one of its high street brands. The 'fast' in fast fashion is closely related to a wider context of fast access in the technology world – the ADSL or broadband that suddenly made the Internet much faster, cheaper and a lot more fun to use. Consumers seem to have unconsciously equated the broadband–web paradigm to everything else around them: demanding that basically, everything should be accessible, fast, plentiful and cheap. So Zara, H&M and other such companies were in the perfect place at the perfect time.

Style consciousness

The fast and cheap context narrated above is basically a quantitative value: lower price and less time. Also at work was the subplot of style consciousness, which is a qualitative value. As the explosion of free media via the Internet became evident, a tidal wave of imagery depicting stylish items and people was there ready to be consumed. New blogs such as Stylehunter and The Sartorialist gave us all a view into the lives of stylish yet ordinary people. These blogs influenced their readers, causing them to attempt to be more stylish, and like a growing snowball rolling down a hill, even more stylish people were added into the mix and fed back into the whole. This growing style hunger could only result in the further supply of stylish goods – and someone had to design those goods.

21st century designers

Today, designers are at the centre of this tidal wave of style and have to respond faster than ever to the ravening stylish mob knocking at their door. The time dedicated to each design has been dramatically reduced as more styles and SKUs (stock-keeping units) are added and delivery times are shortened. This is why it is crucial to know how to use Adobe Illustrator efficiently in order to retain creativity, yet deliver designs accurately and on time.

How to get the best out of this book

This book gathers all the accumulated knowledge and nurtured methodologies that have been tried and tested over my ten years of teaching design students and fashion professionals how to work with Illustrator. Although it is mainly a textbook on how to use Illustrator in a fashion-design context, creativity and design excellence always set the tone. The goal of working faster and spending more time creating rather than processing is also a common thread throughout the book.

I defy anyone to claim they know Illustrator's every feature and menu command: the depth and scope of the program is huge and possibly limitless. This book covers only fashion-related product drawings and ignores any functions and features in Illustrator that are irrelevant. Designers want to get on with the design process and can be put off by over-lengthy and detailed tutorials, so I always ensure that every tutorial is straight to the point, factual and as relevant as possible.

The book lends itself to easy browsing for those who need a quick answer. Evidently it is impossible to display every design detail and issue a designer is likely to face when working in Illustrator, so I invite readers to think laterally and use the content of this book as a basis from which to find their own solutions. I have included learning aims so that readers can benchmark their progress.

A few of the tutorials have elements developed in Adobe Photoshop. I have not given any detailed information about the Photoshop interface, but those who are interested in it may care to look at my book *Digital Fashion Print*. It contains plenty of Photoshop tutorials that link well to this book, as most Photoshop skills are based around surface preparation and textures for filling in flat drawings.

New chapters

One of the big changes from the first edition is the addition of a chapter dedicated to specific issues for footwear, underwear and intimate apparel, jewellery and accessories. Communication is a very important part of a designer's job and so a chapter is devoted to tutorials and tips on how to best communicate your designs. Another chapter contains real gems to save time and help you work faster and more effectively.

Imagine having to take over someone's designs and modify them (a common scenario in most busy studios), swearing out loud while trying to untangle a flat drawing that has been badly put together. The troubleshooting chapter should enable you to do just that, without any worries. It will help you with any issues you may have with common Illustrator or design workflow problems.

Design development

This book is geared to helping fashion designers operating in an environment where speed and accuracy prevail; it will also help students to understand how the design development process really works. Shorter lead times mean that developers need to read flat drawings to copy the details exactly on to garments. In this context, designers have to be precise and fast. As budgets for the development of samples have been cut, designers have fewer sampling rounds to correct any mistakes or misinterpretations. So it is imperative that they pay full attention to their flat drawings, treating them as if they were miniature replicas of the real garment, bag or shoe.

Preparation

To work faster and more accurately, it is important to build a good block library and then move on to a library of design details. Organize yourself well: create resources that you can draw from when deadlines get tight. A big part of the design process is the bringing of different parts such as trims, details and stitches to a design. As such, a good resource library will save you invaluable time. There is nothing worse than having to draw a zip puller from scratch in the middle of a busy delivery schedule.

There are two rhythms to designing fashion with Illustrator: the calm and reflective time when resources are built and consolidated, and the fast and furious time when designs are developed and blazed through to meet deadlines.

Downloadable content

To help you get the best out of this book, we have included downloadable content in many of the tutorials. This new feature enables you to download a fully editable drawing in EPS format, which is compatible with Illustrator from CS3 upwards. Downloadable content will be marked with the Download logo, as follows:

Download

Go to this link to get the files:
www.anovabooks.com/creative-fashion-design-with-illustrator

And finally

We live in a world of rapid response, 'just in time' production processes and constant design changes. More than ever, a design will be judged from a coloured flat drawing made in Illustrator, and so every effort should be put into making that drawing look as good and as close to the final product as possible.

Of course a flat drawing is only a transitional step towards the finished product, whether it is a pair of jeans, fancy shoes or a luxury handbag. So as a designer working with Illustrator, you should always keep in mind this principle: a flat drawing is not the finished product, but it influences the finished product greatly.

Equipment

Computer: Macs and PCs

The tutorials in this book have been developed using an Apple Mac computer, and so all the screen grabs depict an Apple Mac interface of Adobe Illustrator. For PC users, all commands that differ from those on an Apple Mac are clearly highlighted. So if you are using a PC, you can be assured that you will be able to follow all the tutorials on your computer.

When you invest in a new machine, think of the long term. A good computer should last you five years, so pay a bit more for a device with a higher specification and keep it for longer. For a fast workflow, you will need a fairly recent Mac or PC with at least 8GB of RAM and plenty of hard-drive space (500GB). Laptops are very sought-after as their portability makes them a perfect choice for our busy digital lifestyle, and if you make frequent factory visits you will be able to update drawings on the spot and save precious time. Yet desktop computers are much better value for money, with higher specs and larger screen sizes than laptops. It is important to remember that although computers are getting faster and smarter, Adobe CS6 requires a lot of disk space, plenty of RAM and a good graphics card to run smoothly.

Digital tools

Assuming that you are a student, freelancer or someone wanting to start a fashion design studio, you should consider the following when purchasing equipment.

Scanner

Although highly recommended for graphic designers and textile designers, for fashion designers, flatbed scanners have become practically obsolete. Nowadays reference images for trims or details tend to be photographed with a decent mobile phone. The practicality of having a mobile phone always at hand is preferred to the quality that a scanner can deliver.

Graphics tablet

Some people love graphics tablets and some hate them, yet if you can afford to spend the time getting used to working with a tablet, you will be rewarded by a much more intuitive experience when designing on the computer. Unlike Photoshop, Illustrator places less reliance on the pressure-sensitive functions found in advanced tablets, thus you can easily work with an entry-level tablet.

Digital camera

To document and reference your work, a digital camera is essential, so the choice is either your always-at-hand phone camera or a decent digital compact. The most important point, when purchasing, is to have a good CCD chip and lenses.

Printer

Even if the dream of a paperless office is getting closer, there is still nothing more satisfying than a piece of paper for communicating and exchanging ideas. For fashion designers, having a mood board or entire ranges pinned on a wall means you can spread things out to a much greater extent than on the biggest available screens. Invest in a good A3 inkjet printer if you can afford it. For a small design office, a laser printer is more cost-effective and faster.

Storage

From early Illustrator documents with small file sizes to today's bloated mega-files, data has exploded with an insatiable appetite, eating up available storage space faster than ever. Thankfully, the price of storage has fallen, so make sure you invest in ample storage capacity and back up your files regularly. External hard drives and online storage are popular solutions. Cloud computing is the buzzword right now, with global access and security making it a very attractive solution for on-the-go workers.

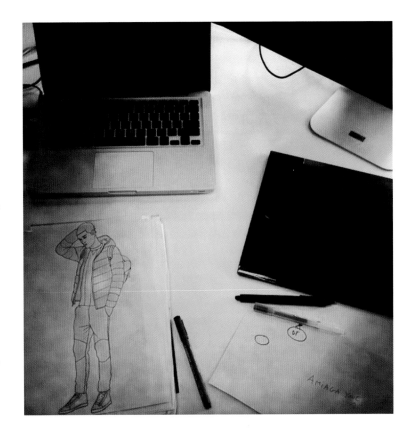

Illustrator CS6
Interface Overview

For Illustrator CS6, the interface has been completely redesigned, as well as the underlying application engine, to bring better performance. The new darker grey look might feel odd to use at first, for those used to the ubiquitous light grey background established more than 20 years ago. This overview introduces the main parts of the interface to ensure novice users don't get lost when starting to work with Illustrator. The layout of the key elements remains the same, and as for most of today's computer-literate users, getting a quick grasp of where things are should not be too much of a stretch. Nevertheless, do spend a bit of time 'making yourself at home' with Illustrator's interface, since you will spend a lot of time here. Like most applications, Illustrator works within the operating system's key element, namely the menu bar, and divides into two distinctive categories: main palettes and functions palettes. Let's have a look at these in more detail below.

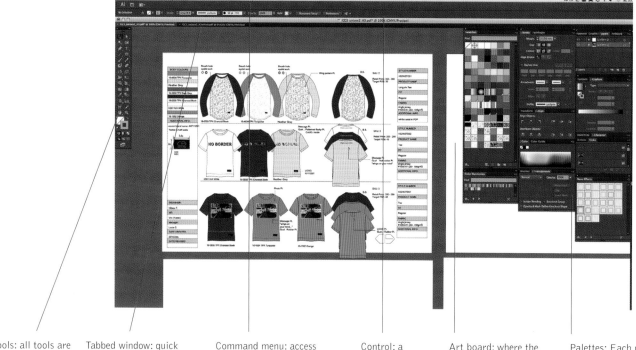

Tools: all tools are located here.

Tabbed window: quick access to open files.

Command menu: access to most functions.

Control: a shortcut for tools in current use.

Art board: where the designs are produced.

Palettes: Each palette controls a key function. All palettes are accessible via the Menu under Window.

New features in Illustrator CS6

Illustrator 6 has a raft of new features that make it really worthwhile to upgrade to it: here are the most important new features for fashion-design usage.

Patterns

The creation and editing of pattern swatches has been simplified. The new pattern options panel gives you a set of options to play with in a much more intuitive way. Select a single design, then go to File > Object > Pattern (this automatically adds the pattern to the pattern palette). Now start having fun experimenting with the palette fields.

Gradient on a stroke

It took a long time, but we finally have it: gradient on a stroke! This new feature will make it much easier to draw gradient effects on strokes quickly, rather than having to do fills that look like strokes. A stroke line made with any tool (pen, pencil or brush) can have a gradient applied to it.

The original artwork.

The resulting pattern tile.

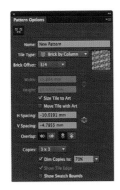

The Pattern Options palette.

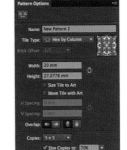

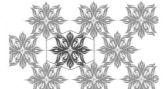

The same artwork with different pattern option settings (which can be changed in an instant), resulting in really different patterns.

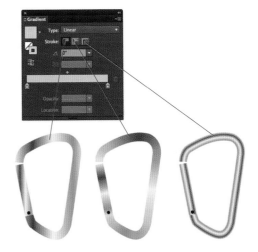

Three strokes with three different stroke selections in the Gradient palette. Note how the last object is a nice, very quick rendering of a karabiner trim using a stroke line.

Fashion design, development and workflow

From initial idea to trade show there are a number of key steps, which are explained below. For a smooth and efficient design development, it is important to understand workflow. Every company has strict calendars and critical paths to ensure the delivery of quality apparel at a precise point in time. The most important aspect to remember is that different types of materials and various techniques require different lead times, and as a designer, you need to be informed about these and to prioritize the development of items with the longest lead times. Each company works in different ways, with different lead times and key stages, yet the workflow below should give you a good insight into how a collection is developed.

Kick-off

This is the start of a season, and there will usually be reports on previous seasons' winners and losers so that designers understand which styles are bestsellers and which have flopped. At kick-off the creative direction will be presented, with mood, concept, colour silhouette, surface graphics and details.

Product briefing

The product team will brief each designer with a range plan containing the product type, price points, SKU numbers, and shape required for each item. For the designer, it is important to get as much sample reference from the product team as possible in order to better understand their requirements.

Design direction

During this first design stage, the design director sets the tone for the collection and works closely with each designer to ensure that the direction is consistent. Key details, colour choice and fabrics are suggested first as they require the longest lead times. At the end of this stage, a mood board for each range with the key colour, details, trim and fabric is presented (see Chapter 9, page 145, for a tutorial on developing mood boards).

Draft design

First designs are drawn in response to the product briefing and design direction. Usually, a designer starts with the more outstanding styles, ensuring a better communication of the design direction. The designs can be hand-drawn or made on the computer; it is most important to leave space for creativity and avoid complacency by cutting and pasting a previous season's designs. (See Chapter 5 for tutorials on developing freehand flat drawings.)

SKU designs

On the SKU sheets, the designer produces all the colourways for each design and modifies the designs according to feedback on the draft designs. Extra attention is given to the details, to ensure that each style works well with the overall collection. The designer must also check that each design is technically feasible and cost-effective. (See Chapter 5 for information on details and fast colouring.)

Sign-off

This is the important stage at which managers, or the director or vice-presidents, sign off the designs on the SKU sheets. It marks the end of the design stage and approves designs going into development. Quite often, sign-off can be delayed because of last-minute modification requests; this underlines the pressure for each design to be perfect.

Technical packs

This is often the most hated stage for a designer, since it is the least creative step towards the finished prototype. Some companies leave the creation of technical packs to supply-chain staff – a clear recognition that designers are reluctant technical pack developers! Technical packs contain as much information as possible and specify, in detail, every component needed to develop a prototype.

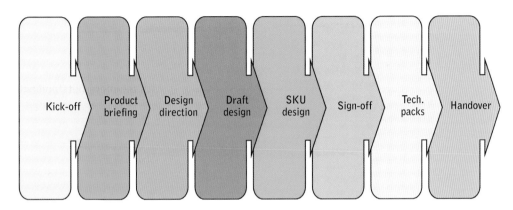

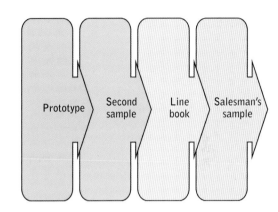

Handover

Once all the technical packs are finished, the designer hands over the files to a developer and goes through the details to ensure that everything is clear and technically feasible. Quite often, changes and updates will be needed as the developer's experienced eye will spot potential problems with certain fabrication issues.

Prototype (or fit sample)

The prototype is constructed to ensure a correct fit and is usually made with a substitute fabric and trims. The designer reviews the sample and corrects any fitting issues. If possible, it is always better to do the fitting at the factory and communicate directly with the factory technicians.

Second sample

Some styles might require a second sample (or even more) if the first fit sample was too far off the mark. Usually, the second sample is made with the real fabric, and all details and stitching should be checked. Changes will be always be required, and usually the technician will request that a designer updates the technical pack. It is important to be on top of your technical pack updates to prevent finger-pointing when the last sample is produced.

Line book

Designers will be requested to supply the sales team with all the SKUs so that a line book can be produced. Line books make useful handouts for customers, where they can note their favourite styles and jot down order quantities or notes. They also form a good reference library of past designed collections.

Salesman's sample

This final sample is a perfect replica of bulk production apparel. Every SKU is produced, and multiple collections are put together for different sales agents. Quite often, still more changes are requested after customers' feedback at trade fairs or other meetings.

Three different ways to illustrate garment drawings

The process of designing apparel in Illustrator has evolved over the past 20 years, reflecting the dramatic changes in computer technology and the capabilities of software. Early on, due to limited processor power, most drawings were flat drawings with simple colour fills. As personal computers grew in power and speed, so did the possibility of doing much more than a simple drawing. Illustrator now has a fully loaded arsenal of capabilities. Three genres of fashion drawing have emerged, each with pros and cons, and each has an audience that requests a particular type of drawing for a particular function. Here, we look at the genres and their key features. Let's start with the original flat drawing, which is the most straightforward way to represent a garment.

Flat drawing

A flat drawing is the representation of a garment (or bag, footwear, etc.) laid flat, usually with full front and back view depiction. This kind of drawing is the closest representation of the 2-D flat pattern required to make the drawn item. It is usually the easiest kind of drawing to design and produce in Illustrator, since most of the lines are geometric. It is also the fastest to update, as it uses the fewest anchor points.

Pros
- Quick to draw.
- Closest to the real pattern.
- Easy to edit.

Cons
- Looks wider than it is when worn.
- Can look blocky.
- Can look lifeless.

Freehand drawing

A freehand drawing is the representation of a garment (or bag, footwear, etc.) as sketched by hand. It usually shows the garment as it would be on a hanger, or as worn standing straight and still. To add a sense of volume, freehand sketches often include creases or folds, but these details remain few and far between to save time and effort.

Pros
- A more realistic look and feel than a flat drawing.
- A good compromise between look and functionality.
- Gives a better feel for the garment's hanger appeal.

Cons
- More time-consuming to design.
- More time-consuming to update.
- More time spent drawing the initial block.

Life drawing

Life drawings of garments are closer to a fashion illustration than to a technical flat drawing. They get the best marks for representing the way that a garment looks and moves when worn, but are the most time-consuming to develop and update. They are a useful way to communicate the mood and feel of a collection.

Pros
- The most realistic kind of drawing.
- Great for visualizing textures and fabric folds.
- Helps in visualizing how a garment should be worn and styled.

Cons
- Very time-consuming to produce.
- Very time-consuming to update.
- Can slow down the application if complex effects are used, due to the large file size.

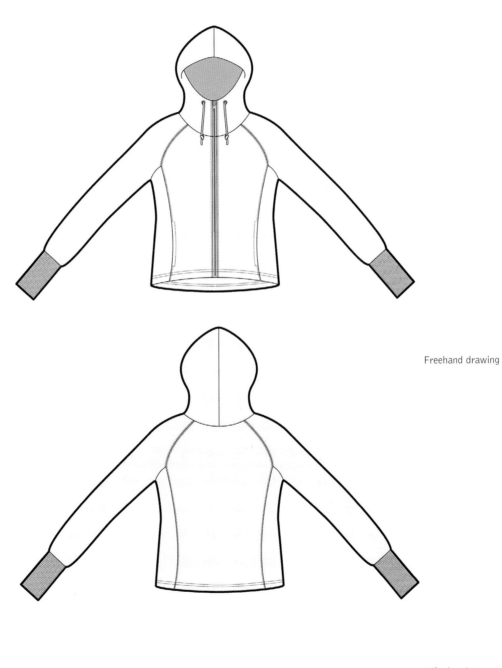

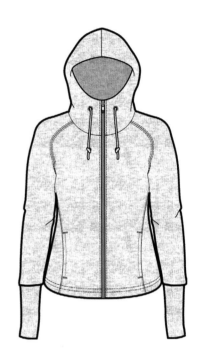

Freehand drawing

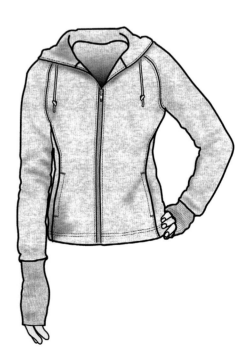

Flat drawing

Life drawing

Chapter 1
Basic drawing foundation

For those who have never worked in Illustrator, this first chapter introduces the way that Illustrator works and will help you to develop basic drawing skills. Most of the content is fast and to the point, with plenty of mini-tutorials. I invite those autodidacts who have learned Illustrator intuitively to quickly go through this first chapter too, because they may find very basic skills or functions that are unknown to them. When starting to work in Illustrator (or any such application), novice users can feel overwhelmed, so this first chapter breaks down the foundations of Illustrator into five key building blocks:

- User interface.
- Object creation and manipulation.
- Creating and directly editing objects.
- Working with colour.
- Working with text.

These five blocks are the absolute essentials for a fashion designer, as you will mainly draw custom shapes (e.g. fashion apparel), edit them, apply colour, and write copy to communicate your designs. All the extra features Illustrator can provide are explained from Chapter 2 onwards. So let's get started with the first key building block: the user interface.

User interface

The introduction to Illustrator's interface on page 12 presents a preview of Illustrator's key parts; here we dig a bit deeper into the user interface with a series of micro-tutorials. Imagine you were getting into a new car: you would naturally adjust the seat and rear-view mirror and feel the driving wheel; the same is true when entering the world of Illustrator. Let's start by familiarizing ourselves with Illustrator's environment.

Create a new document
Once Illustrator has been installed, all the application files will reside in the applications folder (Apple Mac) or in the program files (Windows PC). Mac users will get a program icon in the dock which is a shortcut to launching the application; PC users will access the application via the Start menu. So, launch the application by clicking on the icon shortcut.

Illustrator will present you with a new document window (if no window appears, press Command + N for Mac or Ctrl + N for Windows PC). At this early stage, keep it simple and press OK to create a new default A4 portrait document. Illustrator may also present you with a home window; if this is the case, simply select Create New Document. If you have not done so yet, refer to page 12 for a detailed overview of the main features of the user interface.

Save

To save a document, simply press Command + S (Ctrl + S for Windows PC). You can also access this command using Menu > File > Save. In the first window, select the destination folder or create a new folder. Type in a file name and press Save. In the second window, press OK.

Save As

With this important command you can quickly spawn various versions of a single file. Press Command + Shift + S (Ctrl + Shift + S for Windows PC) to save a file as another version. Type in the required file name. Always save the source file before you do a Save As to create a new file.

New document Create content

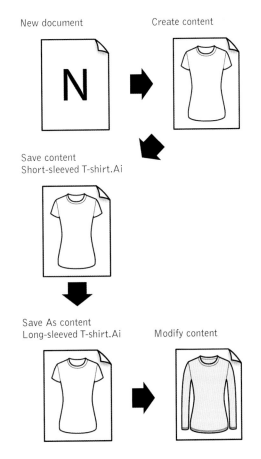

Save content
Short-sleeved T-shirt.Ai

Save As content
Long-sleeved T-shirt.Ai Modify content

Preferences

Illustrator's preferences enable you to fine-tune the way you interact with the application. Here we will only focus on what is needed for all the tutorials in this book. To access the preferences dialogue box, either press Command + K (Ctrl + K for Windows PC) or go to Menu > Illustrator >

Preferences > General (Menu > Edit > Preferences > General for PC users).

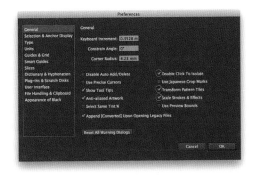

Make sure that Scale Strokes and Effects is ticked; this will keep strokes and effects proportional when resizing artwork. Also tick Transform Pattern Tiles, which allows pattern fills to be transformed. Finally, ensure that Double-Click to Isolate is ticked.

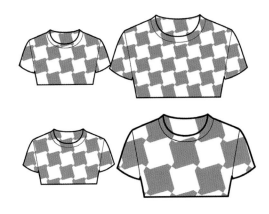

Top: Scale Strokes and Effects and Transform Pattern Tiles are not ticked.
Bottom: With Scale Strokes and Effects and Transform Pattern Tiles ticked.

Navigation

Illustrator's artboard is vast and novice users can easily get lost on it. So here are some different ways to navigate around the artboard.

Scroll bars

This is the old way to navigate and has been part of Illustrator since day one. Scroll bars are usually unwieldy and lack precision. Users with a scrolling wheel on their mouse can directly interact with the scroll bars.

Navigator

The navigator window can be accessed through Menu > Window > Navigator. It is a useful shortcut to go to a required area quickly. The navigator has the benefit of having both a scroll and zoom function. To use it, simply point to the proxy view area (a hand icon will appear), and press and drag to move the artboard around. To zoom, press and drag the zoom slider at the bottom of the window.

Navigator window with zoom slider at bottom.

The hand tool

The unassuming and ancient hand tool still does a great job of navigation or rather moving the artboard around. One reason it is still so popular is its simplicity and ease of access. Click H on your keyboard or, as most seasoned designers do, press and hold the space bar to transform any current tool into the hand tool (except the type tool, for which you will first need to press Esc).

The hand tool.

Zooming

Illustrator has several ways to zoom in and out: find which one suits you best. You can use the navigator window to easily zoom in and out by using the zoom slider. You can also use a keyboard shortcut to zoom in: press Command with the + key (Ctrl with + for Windows PC). To zoom out, use Command with the − (minus) key (Ctrl with − for Windows PC). This technique is fast but lacks precision as the zoom always goes straight forward.

The best way is still to use the zoom tool, accessed by clicking Z on the keyboard or from the toolbox. Using the keyboard shortcut is faster still: press Command + space bar (space bar + Ctrl for Windows PC) to change any tool into the zoom-in tool (except the type tool, for which you will first need to press Esc).

Press and drag a frame that equates to the area you want to zoom into. To zoom out, press Command + space bar + Alt (space bar + Ctrl + Alt for Windows PC).

The zoom tool.

Use press and drag with the zoom tool to go where needed in a single step.

Viewing modes

Illustrator has four viewing modes; the following are the most important ones.

Preview mode

This is the full-colour, full-resolution mode, which is the same as will be displayed on paper by your printer.

Outline mode

Outline is a wire-frame view of your artwork, without any colour or effects. Press Command + Y (Ctrl + Y for Windows

PC) to switch to outline mode and the same again to switch back to preview mode. (Preview and outline modes can also be accessed via Menu > View > Outline/Preview.).

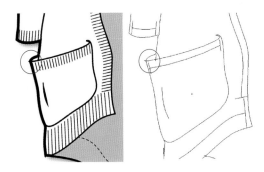

At close range, this design shows some misaligned details (left). With the outline viewing mode on, it becomes much easier to adjust misaligned paths (right).

Pixel preview mode

This is useful when artwork is full of high-resolution images, which slow a computer's speed quite notably. Press Alt + Command + Y (Ctrl + Alt + Y for Windows PC).

Panels and workspaces

Panels are interactive windows that allow you to modify your work. Most panels have the same layout and you interact with them in the same way. For a good set-up for fashion design, select the following windows: colour, swatches, brushes, stroke, transparency, layers, appearance, symbols, pathfinder and text.

Close Tab Option Collapse to icon

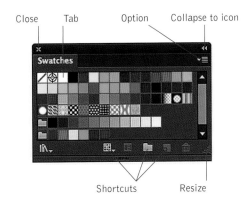

Shortcuts Resize

Swatches panel.

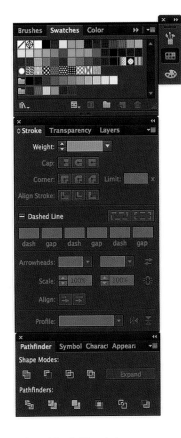

Windows selected for fashion design.

Workspaces are a useful feature for those who work on screens of different sizes (for example when you connect your laptop to a big screen). Workspaces also allow you to arrange palettes and windows in a specific way and to save the layout so it can be recalled at any time. To set a workspace, do the following. Select from the window menu the windows you require. Arrange them, trying to save as much space as possible. When you select a window from the list, it will usually appear on the workspace grouped with other windows; you can easily separate the windows by pressing and dragging the window tab. When a window stands alone, it can be closed by clicking on the top left-hand button.

Name the workspace and press OK. You can always recall this workspace by selecting it from the list in the workspace menu.

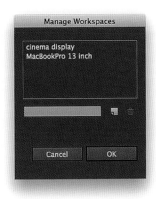

Artboards

Artboards enable you to have several pages laid out on a canvas. For example, in fashion design, an entire range or collection can be displayed on several A3 pages, thus enabling designers to work on all designs in a single document.

To set up artboards when creating a new document, select the number of artboards you want in the appropriate box, and then select the size of artboard.

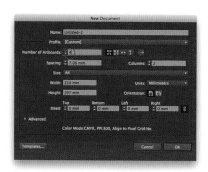

The artboard tool.

To add artboards to an existing document, select the artboard tool and in the control panel, press the New Artboard icon. Place the new artboard on the canvas manually. Or, in the artboards panel (Menu > Window > Artboards), press the New Artboard icon. Artboards can easily be deleted via the artboards panel by selecting an artboard and pressing the Delete Artboard icon, or with the artboard tool by clicking on the small cancel box at the top right of any artboard.

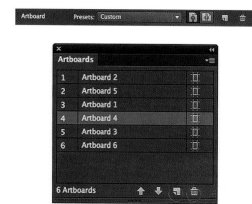

Guides and smart guides

For tasks such as alignment, guides are a great help. Smart guides are an added bonus for a more intuitive design experience. This is how to use them.

- To start working with guides, go to Menu > View > Rulers > Show Rulers (Command + R; or Ctrl + R for Windows PC).
- To draw a vertical ruler, go to the ruler on the left-hand side of the window, press and drag the ruler on to the artboard and release at the desired position.

- To delete a guide, point to the guide, press Command + Shift, and double-click then press Delete (for Windows PC, press Ctrl + Shift).
- To lock guides, go to Menu > View > Guides > Lock Guide.
- To hide or show guides, go to Menu > View > Guides > Hide/Show Guides. Or use the shortcut of Command + ; (Ctrl + ; for Windows PC).
- To work with smart guides, go to Menu > View > Smart Guides (Command + U or Ctrl + U for Windows PC).

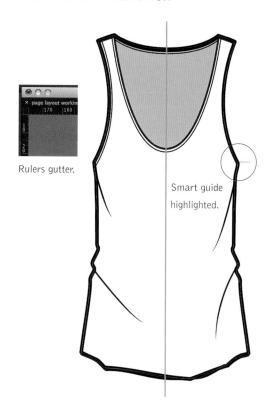

Rulers gutter.

Smart guide highlighted.

Guide used as centre-front line.

Layers

Layers help designers organize their work in different levels for efficiency and productiveness. The main advantage of layers is the ability to lock and hide elements within a layer, thus enabling the user to better visualize work in progress or avoid moving objects around unintentionally. The methodology for designing garments and accessories in this book relies on layers. Here is a quick introduction to layers.

- To access the Layers palette, go to Menu > Window > Layers (or press F7).
- To create a new layer, press the New Layer icon in the Layers palette.
- To rename a layer, double-click on its instance in the Layers palette.
- To hide a layer, press the Toggle Visibility icon.
- To lock a layer, press the Toggle Lock icon.
- To delete a layer, press the Delete Selection icon.

Toggle Visibility icon

Toggle Lock icon

Layer instance

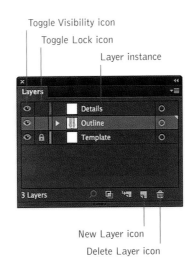

New Layer icon

Delete Layer icon

Layer composition.

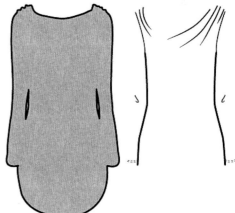

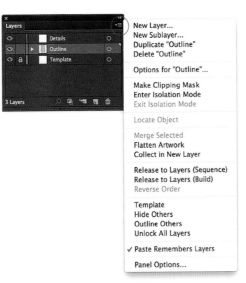

Outline Details

Object creation and manipulation

Illustrator's vector objects are made up of segments and anchor points; the application uses bounding boxes to further manipulate objects once they are created.

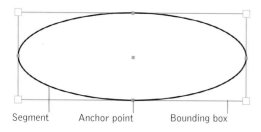

Segment Anchor point Bounding box

Predefined shapes

The easiest way to draw objects in Illustrator is to use the application's predefined shapes. It is always much quicker to design objects from prime shapes (for example, a four-hole button can be drawn by compounding several ellipse shapes) than drawing them from scratch. Illustrator has five predefined shapes: rectangle, rounded rectangle, ellipse, polygon and star. All these are located in the toolbox.

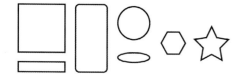

Illustrator's five predefined shapes: rectangle, rounded rectangle, ellipse, polygon and star.

To access predefined shapes:
• Point to the toolbox on the rectangle tool, press and wait until the sub-menu appears,

point to the tear-off margin on the right-hand side, and release the button.

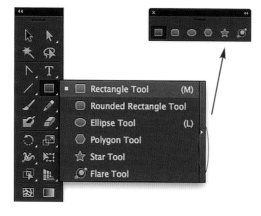

To create objects:
• Select any object tool, point to the artboard, press and drag to draw, and release button to finish.
• To make circles (with the ellipse tool) or squares (with the rectangle tool), press the shift key while dragging (always release the button before the key).

To create objects of a specific size:
• Select any object tool, click on the artboard, and in the floating palette enter a value for width and height. Press OK.

Stars and polygons:
• To define a star's point or a polygon's sides, input values in the respective floating palettes.

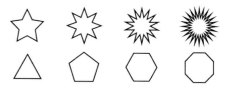

The star object with various amounts for the points; the polygon object with various amounts for the sides.

Select and move objects

The selection tool (black arrow) enables you to select and move objects around:
• Point and click the selection tool in the toolbox or press V.
• To select an object, point and click.
• To move an object, point and then press and drag; release the button to finish the move.
• Use the arrow keys to move selected objects vertically and horizontally.

Normal | Above object path | Above object anchor point | Above object fill

To successfully select or move objects, the selection tool must have its icon changed as illustrated above. Objects without a colour fill can only be selected if on a path or anchor point line.

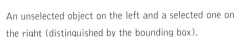

An unselected object on the left and a selected one on the right (distinguished by the bounding box).

- To select more than one object, click on the first one and then press the shift key while clicking on the second one.
- To select several objects in one go, press and drag over the area, covering all the required objects.

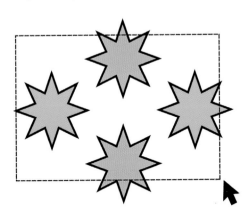

- To deselect all objects, click any empty space on the artboard (click away).
- To select all objects at once, press Command + A (Ctrl + A for Windows PC).
- To deselect all objects at once, press Command + Shift + A (Ctrl + Shift + A for Windows PC).
- To select all objects on an active artboard, press Command + Alt + A (Ctrl+ Alt + A for Windows PC).

- To delete objects, select them and then press the delete key or backspace key.

Scale and rotate objects

Once an object is selected, you can easily manipulate it using the bounding box. To practise this, pick the black arrow and then hover around the bounding box's corners and middle segments. Notice how the icon is updated.

Scale width Scale height Scale height and width Rotate

- To rotate, position the selection tool on any corner of the bounding box, slightly outside the box, and press and drag.
- To scale vertically or horizontally, position the selection tool on the middle segment points of the bounding box, and press and drag.
- To scale both horizontally and vertically, position the selection tool on any corner point, and press and drag.
- To constrain-scale (keep proportional), press the shift key while dragging.
- To constrain-rotate (rotation fixed to 45° and 90°), press the shift key while dragging.

For more precision, use the scaling and rotation tools, which allow you to input a scale percentage or rotation angle.

- To scale, select any object, pick the scaling tool (S) in the toolbox, click on the artboard and input the scale percentage.
- To rotate, select any object, pick the rotation tool (R) in the toolbox, click on the artboard and input the degree of rotation.

The scaling tool. 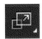 The rotation tool.

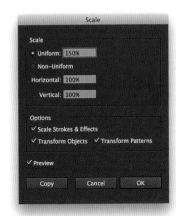

The scaling dialogue box.

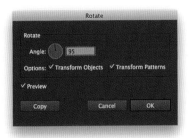

The rotate dialogue box.

Scaling and rotation using the bounding box or the scaling tool and rotation tool is fast, but lacks the precision to truly alter a design's proportions. The main usage for scale in this context is to change a design's size proportionally to fit a layout. The Rotate function allows slight rotation or 90° rotations to fit a layout. Nevertheless, the speed with which you can alter vertical and horizontal proportions using the bounding box can be useful in order to do a fast visualization before more detailed alterations.

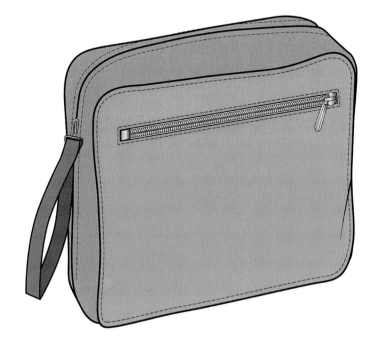
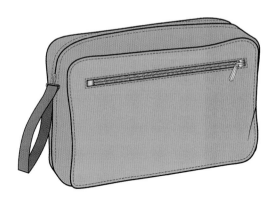
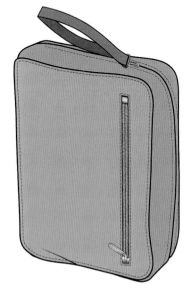
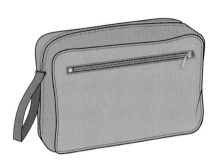
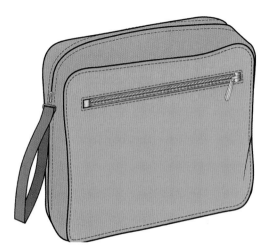

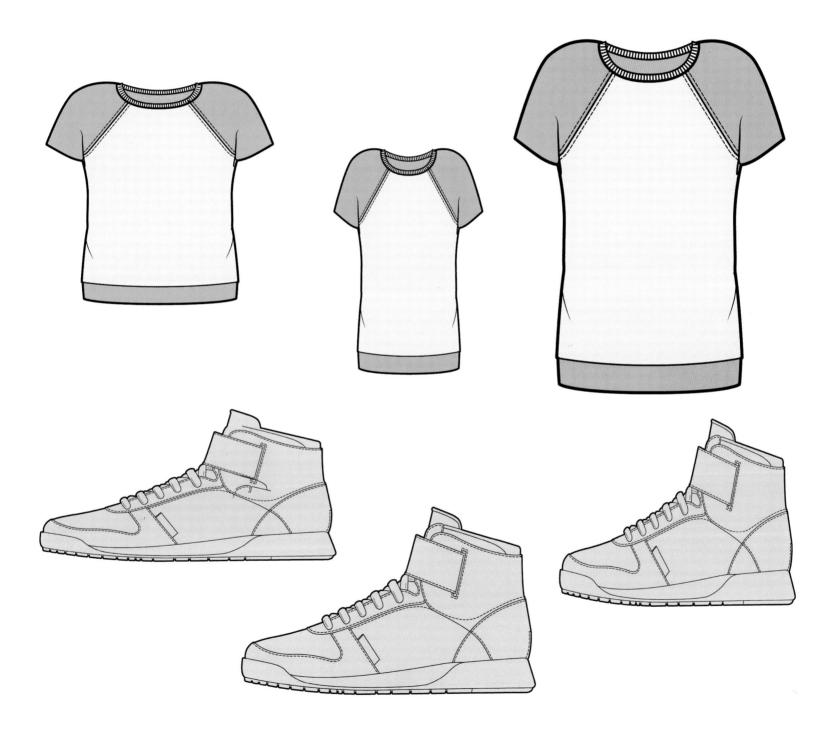

Copy, cut and paste

These basic editing operations are used often and form the foundation of many techniques displayed in this book. These functions are accessible through Menu > Edit > Copy/Cut/Paste, but it's quicker to use keyboard shortcuts:

- To copy an object, select it and press Command + C (Ctrl + C for Windows PC).
- To cut an object, select it and press Command + X (Ctrl + X for Windows PC).
- To paste an object, select it and press Command + V (Ctrl + V for Windows PC).

Beyond these three basic editing functions, found in most applications, Illustrator has more advanced pasting functions:

- To paste in front, copy an object and press Command + F (Ctrl + F for Windows PC).
- To paste at the back, copy an object and press Command + B (Ctrl + B for Windows PC).
- To paste in place, copy an object and press Command + Shift + V (Ctrl + Shift + V for Windows PC).
- To paste an object on all artboards, copy it and press Command + Alt + Shift + V (Ctrl + Alt + Shift + V for Windows PC).

The commands Copy, Paste in Front and Paste in Back allow you to position a duplicated object in the same position but either above or below the original object.

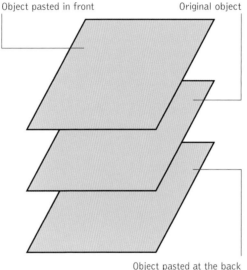

Object pasted in front Original object

Object pasted at the back

You can paste copied objects on multiple artboards, which is very useful when preparing a document with several pages (a portfolio or a technical pack).

Spring Summer
2015

My Brand

Spring Summer
2015

My Brand

Arrange the stacking order

Illustrator places every newly created object above the previous one, so the older the object, the lower it is in the stacking order. Create several different objects on top of each other to try out stacking-order functions.

- To send an object to the bottom of the stacking order, select it and press Command + Shift + [, or do a right click and select from the floating menu: Arrange > Send to Back.
- To send an object to the top of the stacking order, select it and press Command + Shift +], or do a right click and select from the floating menu: Arrange > Bring to Front.
- To send an object one step back in the stacking order, select it and press Command + [, or do a right click and select from the floating menu: Arrange > Send Backwards.
- To bring an object one step up the stacking order, select it and press Command +], or do a right click and select from the floating menu: Arrange > Bring to Front.

All these functions can also be accessed through Menu > Object > Arrange, but again it is a slower process than using the keyboard.

The same objects with different stacking orders.

Undo and redo

Illustrator can undo and redo every step taken during a design session, so for any mistake made, the user can go back to the offending step. It is also possible to go forward again using the Redo command if the user has gone too far back in time (this mostly happens when the offending step occurred many steps previously).

- To undo, press Command + Z (Ctrl + Z for Windows PC).
- To redo, press Command + Shift + Z (Ctrl + Shift + Z for Windows PC).

Note that an undo and a redo can only occur while the document is open: after closing a document, all undoing and redoing capabilities are lost.

A workflow with an error followed by the undoing and redoing steps.

Move and duplicate

We have looked at how to move objects freely: now we'll learn how to move them using the Move function.

- To move an object a set distance, select the object, press Command + Shift + M (Ctrl + Shift + M for Windows PC), and in the floating palette input the required distance or position. Press OK.
- To duplicate using the Move function, do as above but press Copy rather than OK.

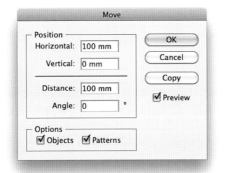

You can also access the Move function by pressing the enter/return key or by right-clicking and then selecting Transform > Move.

The Duplicate function is a useful feature to quickly replicate a move/copy operation and thus create a row or column of similar objects spaced evenly (a row of buttons, for example).

- To duplicate a move/copy operation, start by moving and copying the object as below, then press Command + D (Ctrl + D for Windows PC).

Transform Each

With this feature, you can transform an object's scale as well as moving it.

- To Transform Each, select an object, press Command + Shift + Alt + D (Ctrl + Shift + Alt + D for Windows PC) and in the floating palette, input a move and scale value. Tick Preview to visualize. Press OK, then as above press Command + D to duplicate the Transform Each operation. To learn how to use Transform Each for gradient stripes, see page 86.

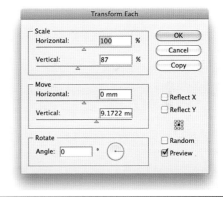

Using Transform Each to create a gradient stripe.

Duplicating freely

We have already looked at duplicating using the Move/Copy/Duplicate function, yet there is a more intuitive way to duplicate, using the alt key.

- To duplicate freely, select an object, move it and press alt. Release the mouse or trackpad button before the alt key.
- To make several copies of the same object, keep the alt key pressed after releasing the mouse or trackpad button, then press/release the button again for each new copy of the object.

Press and release the trackpad button while continuously holding down the alt key.

Constraining

Constraining restricts any action – such as moving, scaling, rotation or duplication – to set parameters. For example, a constrained rotation will only allow 45° and 90° angles. Constraining ensures that objects are aligned or scaled proportionally.

- To scale-constrain: Select the object, and using either the bounding box or the scaling tool, press and drag, then press and hold the shift key. Always release the button before the shift key.

- To rotate-constrain: Select the object, use the rotation tool, press and drag in a circular motion, and then press and hold the shift key. Always release the button before the shift key.
- To move-constrain: Select the object, press and drag, then press and hold the shift key. Always release the button before the shift key.

Scale-constrain to keep the drawing proportional.

Rotate-constrain at 45° and 90° angles using the rotation tool and shift key.

Move-constraining enables you to move an object horizontally, vertically or diagonally.

Duplicate and constrain freely

Objects can be moved, duplicated and constrained freely all at the same time. This is a very fast way to spawn several copies of one object. It is the same as the Move function, using Copy, but it is done by using just the keyboard's alt and shift keys, thus it is much faster than inputting move distances via the Move dialogue box.

- To move and constrain: select the object, press and drag, and then press the alt and shift keys. Release the button before the keyboard keys.
- To duplicate the exact same move, constrain-duplicate, do as above and then press Command + D (Ctrl + D for Windows PC).

Align and distribute

Objects can easily be aligned and evenly distributed using Illustrator's Align function. It is accessed either via the Control palette (when objects are selected) or through the Align palette (Menu > Window > Align). Press the pop-up menu to show the options (as illustrated).

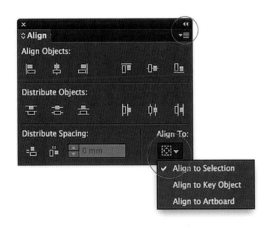

The Align palette, with the Align To menu.

- To align objects, select at least two objects, press the required alignment (horizontal: left, right; centre vertical: left, right, centre).
- To distribute objects, select at least three objects and press the required distribution (horizontal: left, right; centre vertical: left, right, centre).

Unaligned objects.

Objects with vertical alignment.

Objects with centred horizontal distribution.

Alignment and distribution can be relative to selection (object selected), to the artboard, or to a key object.

- To align or distribute relative to an artboard, select the artboard in the Align To menu, then align as above.
- To align or distribute relative to a key object, select the artboard in the Align To menu, then input a value in Distribute Spacing and press the vertical or horizontal Distribute Space icon.

Object aligned to the artboard.

Objects aligned to a key object (centre).

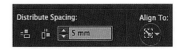

Key object alignment selected.

Group and ungroup

It is useful to group objects when several objects constitute a single entity (for example several shapes making a pocket). This will prevent objects from being parted by mistake.

- To group objects, select more than one object, press Command + G (Ctrl + G for Windows PC).
- To ungroup objects, select the group, press Command + Shift + G (Ctrl + Shift + G for Windows PC). The grouping and ungrouping functions can also be accessed through Menu > Object > Group/Ungroup or by right-clicking via the contextual menu.

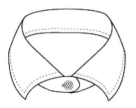 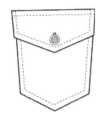

A collar and a pocket made of several objects, both grouped as a single entity.

Groups within groups

It is good practice to build different groups within a complicated object, for example a shirt can be made up of several sub-groups – such as pockets, collar, cuffs – which are in turn grouped together to form a single object. When a complicated object with sub-groups is ungrouped, first ungroup the whole, then ungroup each sub-group one by one.

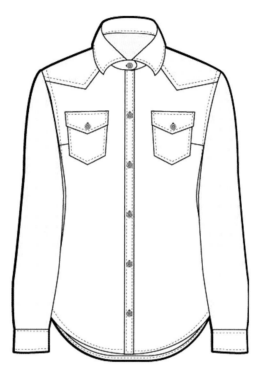

Grouped shirt object with several sub-groups (pockets, collar, cuffs, etc.).

Lock and unlock

Objects can be locked to facilitate workflow and prevent unnecessary movement. Usually, objects that get in the way are stowed in locked layers, but sometimes it is faster to quickly lock an object and proceed with the work at hand.

- To lock any object, select it and press Command + 2 (Ctrl + 2 for Windows PC).
- To unlock any object, select it and press Command + Alt + 2 (Ctrl + Alt + 2 for Windows PC).

In the Layers palette, under the sub-layers listing, grouped objects are listed as one line and can thus easily be selected and locked or hidden.

- To access grouped objects in the sub-layers listing, go to the Layers palette and press the sub-layers toggle. Go down the listing until you spot the required group (usually listed as 'Group').
- To rename a sub-layer group, double-click on it and type in the new name.

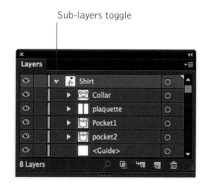

The Layers palette with sub-layers listed and renamed.

Hide and show all

Objects can be hidden and revealed to facilitate the viewing of other objects, or when objects are pasted in front of or behind objects, making them difficult to select.

- To hide an object, select it and press Command + 3 (Ctrl + 3 for Windows PC).
- To show all hidden objects, press Command + Alt + 3 (Ctrl + Alt + 3 for Windows PC).

Isolation mode

When several objects are grouped into one, it is not possible to manipulate individual parts of the group (unless using the white arrow – see page 38). Isolation mode enables users to do direct manipulation on grouped objects without having to ungroup or switch to the white arrow. When using isolation mode, the selected object is isolated from all others, so users can focus work on the selected object.

- To enable isolation mode, select a grouped object: either double-click it or press the Isolate Selected Objects button in the control panel.

The Isolation Mode icon on the control panel.

Isolation mode view

Once inside isolation mode, you can easily edit, scale, rotate, colour etc. the isolated object.

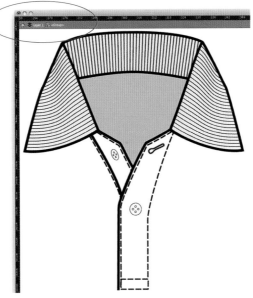

The collar and neck detail is a grouped object, now in isolation mode; the inside of the neck view is isolated to be edited. The icons in the top left-hand corner represent the level of isolation.

Isolation mode view, group within group

If some objects are still grouped (group within a group) within isolation mode, double-click again to access them.

- To exit isolation mode, either press the Esc key on the keyboard or the Exit Isolation Mode button (same as the Isolate Selected Object button).

The button is grouped within the collar and neck detail object, and thus is accessed by a further double-click. Note the top left-hand corner icons with an added level of group.

Learning aims

We have reached the end of the second drawing skills foundation. You should now be able to do all the basic manipulations using predefined objects, and understand all the basic principles relating to the way that Illustrator works and how the user interface functions. If you still feel unsure about any parts of this section, I suggest you experiment until you really feel comfortable with these skills. Some of them are used so often that they should become second nature to you.

Creating and directly editing objects

This section looks at how to create objects from scratch using the pencil and pen tools and how to edit objects directly using the white arrow (direct selection tool).

The pen and pencil tools.

Creating objects using the pencil tool

The pencil tool is a freehand tool, which draws segments and anchor points. Using it is very simple, but mastering it is more tricky. For a better experience, use a graphics tablet when working with it.

- To draw using the pencil tool, select it in the toolbox, and press and drag it on the artboard.

A line made up of segments and anchor points, drawn with the pencil tool.

Fine-tuning the pencil pool
For the best drawing experience, you will need to fine-tune the pencil tool. Each parameter will substantially change the appearance of drawn lines.

- To fine-tune the pencil tool, double-click on its icon in the toolbox and set the parameters to suit your drawing style. Press OK.

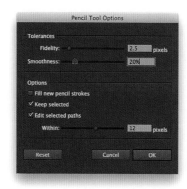

The pencil tool options window.

Fidelity
Sets the distance between anchor points on a drawn path. A high value results in fewer anchor points.

Smoothness
Controls how smooth a drawn path is. A high value results in a smoother yet less detailed line.

Fill New Pencil Strokes
Applies a fill to drawn pencil strokes.

Keep Selected and Edit Selected Paths Within Pixels
If Keep Selected is ticked, it will keep the drawn path selected and try to link it with the next drawn line. Edit Selected Paths

Within Pixels determines how close the mouse or stylus must be to an existing path in order to connect to the following one.

Two similar lines with different fidelity and smoothness settings.

You can draw closed shapes using the pencil rather than open lines:
- To draw closed shapes, start by drawing a line as usual, then press the alt key (Option for Windows PC). The pencil will have a small circle next to it; when you release the button, the line will automatically join the first anchor point to close the shape.

You can reshape a path using the pencil tool:
- Select the path to change, and place the pencil tool on the path to redraw it. Press and drag to reshape.

Creating objects using the pen tool

The pen tool draws straight lines and curves accurately; it is the most commonly used tool for making flat drawings. Curves require more skill and this is usually the more difficult part of drawing with a pen tool. Let's start with simple straight lines.

To draw straight lines using the pen tool:
- Select the pen tool in the toolbox.
- Click on the artboard to place the first anchor point.
- Move to position the second anchor point and click again: this will draw a segment.
- Continue moving and clicking to set more straight line segments.

To finish drawing, you can either:

- Create a closed path by positioning the pen tool on top of the first anchor point and clicking (a small circle will appear next to the pen tool). Or:
- Leave the path open, by pressing Command + click (or Ctrl + click for Windows PC) and clicking away on the artboard.

You can easily draw straight or 45° lines when working with the pen tool by pressing the shift key while clicking to place an anchor point. You will only need to position the anchor point roughly in the required location so that Illustrator can determine if it is a straight segment or a vertical line etc. You can reposition anchor points as you draw, which is very useful when you draw symmetrical objects such as the one below.

- Rather than clicking to create an anchor point, press the button and hold down the space bar, then drag to reposition the anchor point.

Repositioning an anchor point.

Drawing curves with the pen tool

Curves in Illustrator work under the Bézier curve principle, which is an anchor point with a curve handle, where the handle's length and position affect the curve's length and depth. It is best to use as few anchor points as possible when drawing several curves (for example a armhole followed by a waist and hip curve) to get a smooth result.

Two curves with different handle positions.

To create a curve:
- Select the pen tool in the toolbox.
- Position the pen where you want the curve to start, and click to place the first anchor point.
- Move to where the curve needs to end, and press and drag to create a curve.

To create a constrained curve:
- Select the pen tool in the toolbox.
- Position the pen where you want the curve to start, and click to place the first anchor point.
- Move to where the curve needs to end, and press and drag to create a curve.
- Before releasing the press and drag, press the shift key.

Constrained curve (90°).

To create a straight line followed by a curve:
• Select the pen tool and draw a straight line using two anchor points (press the shift key to constrain). Place the pen tool over the second anchor point. An inverted 'V' icon will appear next to the pen tool. Press and drag to create a curve handle, move away to position the third anchor point, and press and drag to create a curve.

A straight line followed by a curve.

To create a curve followed by a straight line:
• Select the pen tool and draw a curve using two anchor points. Place the pen tool over the second anchor point. An inverted 'V' icon will appear next to the pen tool. Click to cancel the curve handle, move away to position the next anchor point, and click again to create a straight line (press the shift key to constrain).

A curve followed by a straight line.

To create curves with corners between:
• With the pen tool, press and drag to create the first anchor point, and position the pen further along to create a curve with a second anchor point.
• Press and drag, then press and hold the option key (alt key for Windows PC) and drag the curve handle into a different direction. Release the key and mouse button.
• Position a third anchor point to produce the second curve.

Curves with corners.

Finishing working with the pen tool

When you are drawing an object with the pen tool and want to finish it to create a new one, you should either:
• Create a closed path object (see previous page).
• Leave a path open by pressing Command and clicking away (Ctrl and clicking away for Windows PC).
• Or select a different tool or Menu > Select > Deselect.

A closed path object (buttonhole).

Several open-path objects made with the pen tool.

You should now have a good understanding of how the pen and pencil tools work, and should be able to start drawing visually pleasing content. To inspire you, here are a few objects and style lines drawn using the skills you have just learned. The main learning aim for novice users is to understand how to use the pen and pencil in a way that feels natural. It becomes much easier to draw beautiful lines and objects when these tools are fully mastered.

Editing objects

After designing objects, it is very important to edit them. This step ensures that designs are well thought through and reviewed to cancel any of the unsightly flaws usually associated with first drafts. Having an editing step also enables users to work faster when drafting a design, in the full knowledge that a second step will result in a more polished output.

Illustrator has several tools for editing designs, yet the most commonly used is the white arrow (direct selection tool), which can select individual anchor points directly. The pen and pencil tools also contain sub-tools to edit objects directly, such as the add/delete/convert anchor point tools for the pen tool and the smooth/path eraser tools for the pencil tool.

Editing with the white arrow

The white arrow can directly edit the position of single or multiple anchor points, the position and curvature of segments, and the position and length of curve handles. Here is the lowdown on how to edit objects directly using the white arrow.

The white arrow has a context-sensitive cursor, which adds a small square icon to confirm which area of an object is about to be selected. A dotted white square denotes the selection of individual anchor points. A black square denotes the selection of a segment.

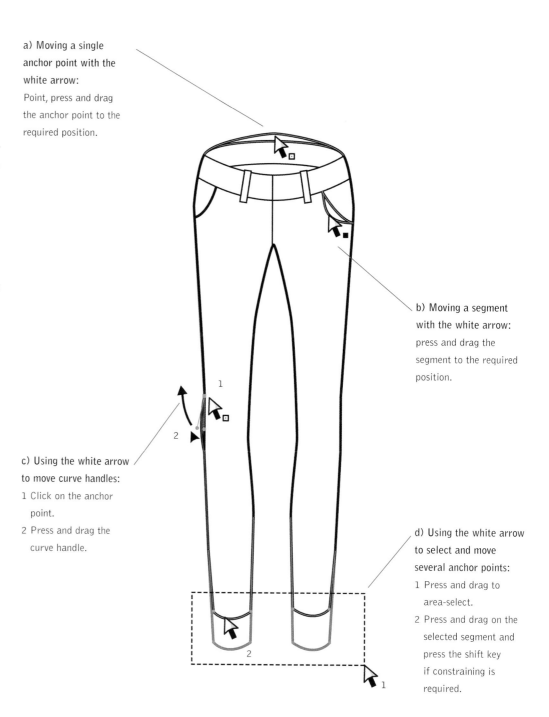

a) Moving a single anchor point with the white arrow:
Point, press and drag the anchor point to the required position.

b) Moving a segment with the white arrow:
press and drag the segment to the required position.

c) Using the white arrow to move curve handles:
1 Click on the anchor point.
2 Press and drag the curve handle.

d) Using the white arrow to select and move several anchor points:
1 Press and drag to area-select.
2 Press and drag on the selected segment and press the shift key if constraining is required.

Average and join

Averaging is used to align anchor points on a vertical or horizontal axis, while the joining of anchor points is used to either close a single open shape or two open shapes.

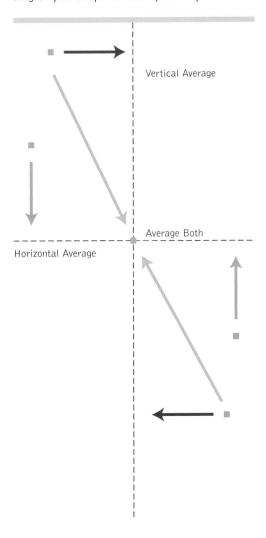

Vertical Average

Average Both

Horizontal Average

Selected points can be averaged on either
a vertical or horizontal axis, or on both.

- To average, select with the white arrow at least two anchor points, then either press Command + Shift + J (Ctrl + Shift + J for Windows PC) or do a right click > Average. Then select the axis and press OK.

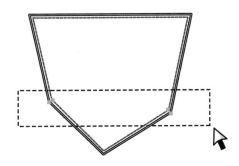

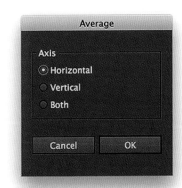

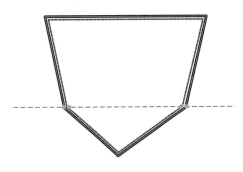

- To join anchor points to close a gap, select two anchor points only, then press Command + J (Ctrl + J for Windows PC).

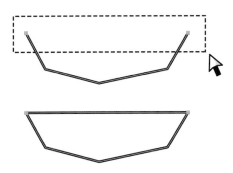

- To average and join open shapes, select two anchor points only, then press Command + Shift + J (Ctrl + Shift + J for Windows PC).

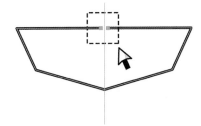

- In the Average dialogue box, press Both then OK; immediately after this, press Command + J (Ctrl + J for Windows PC).

Editing with pen and pencil tools

The pen tool's add/delete/convert anchor point tools and the pencil's smooth/path eraser tools are specifically designed to edit objects further, and help with fine-tuning first drawings. It is important to note that both the pen and pencil tools can also be used to edit objects directly, for example the pen tool can add and delete anchor points just like the add/delete/convert anchor point tools: it is usually faster since there is no need to change tool during the editing process. The pen and pencil editing tools are found embedded within the pen and pencil toolbox's sub-menus, and accessed by pressing to the lower right of the tool's icon (circled).

Top row, left to right: The add anchor point tool; the delete anchor point tool; the convert anchor point tool. (Bottom row, left to right) the smoothing tool; the path eraser tool.

a) Erasing paths:
With the path eraser tool, press and drag over an area to erase it.

c) Adding and deleting anchor points:
With the add/delete anchor point tool, click on the anchor points.

b) Smoothing a segment:
With the smoothing tool, press and drag over an area to smooth it. Double-click the tool to change settings.

d) Converting anchor points:
Using the convert anchor point tool, press and drag to create a curve or click to delete a curve.

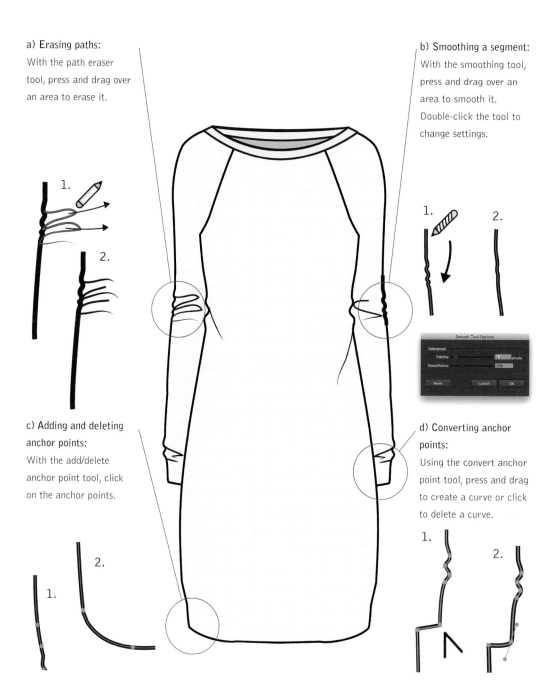

Editing an object with eraser, scissors and knife tools

Illustrator has grown over the years and in the process, several editing tools have been added to its arsenal; it's important for new users to try them all and see which one suits their needs best. Try out these tools using the downloadable version of the drawing shown right.

The eraser tool's sub-menu is accessed by pressing to the lower right of the icon.

The eraser, scissors and knife tools. The latter two are accessed by pressing to the lower right of the tool's icon.

The eraser works and acts just like a real eraser. Make sure that when working with this tool, you first select the object to erase. The scissors tool is useful when paths spill over and need a precise trimming. The knife tool is useful for slicing closed objects into two halves.

a) Cutting path:
With the scissors tool, click on the segment to cut. To delete the extra segment, use the black arrow, select and press Delete.

b) Erasing paths:
Select the path to erase, then with the eraser tool, press and drag over the area to be erased. To fine-tune and change the eraser's diameter, double-click on the tool to access the eraser's options.

c) Slicing objects:
Select a closed object. With the knife tool, press and drag across the object – either freehand or press Alt (Option for Windows PC) to cut straight. Always slice right through an object.

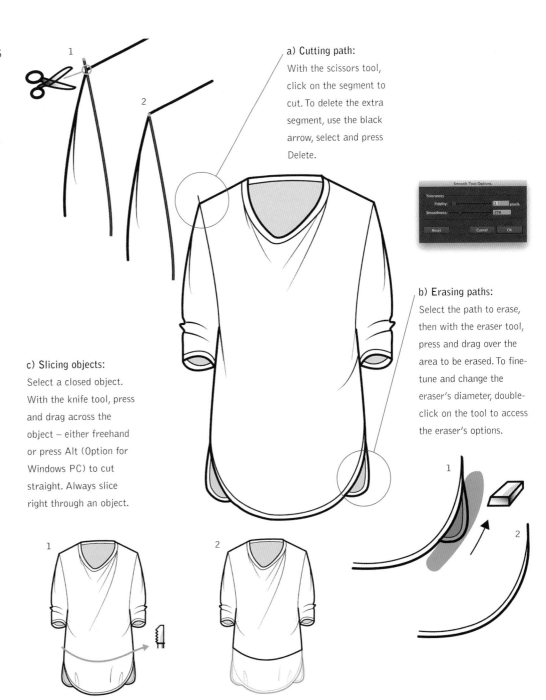

Object strokes

Before filling in objects with colour, let's look at how Illustrator manages object strokes. By default, Illustrator applies a stroke of 1pt to all new objects. Yet by varying the stroke weight of a flat drawing, a much better look and feel – and most importantly, readability – can be achieved.

Two identical buttons, yet the one on the left, with a different stroke weight, has more depth and definition.

All stroke operations are set from the Stroke palette (Menu > Window > Stroke or Command + F10; Ctrl + F10 for Windows PC). Ensure that you have access to all the available options by selecting Show Options in the pop-up menu.

The Stroke palette

Let's look in detail at the Stroke palette with all its options.

a) Weight:
Select an object and either type in the weight or select from the pop-up menu (you can input millimetres too).

c) Cap and corner:
Select the object and change the cap and corner by ticking the chosen box.

The same topstitch with a different cap and corner.

d) Profiles:
Give a more freehand feel to your flat drawings using profiles by selecting from a range of pre-designed profiles found in the pop-up menu.

Drawing with a flat profile on the left and a pre-designed profile on the right.

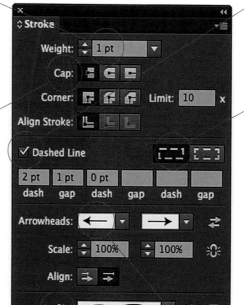

b) Dashed lines:
Select an object and tick Dashed Line, then input values in the first dash and gap boxes.

Dashes can either be preserved or adapted to fit the drawing. Tick the left-hand box for a more realistic look to topstitching.

The same design with a different dash and gap.

e) Arrowheads:
You can easily add arrowheads to a segment; useful for technical packs.

Stroke language

Using the right kind of stroke weight, dash and profile can greatly enhance the look and feel of a flat drawing. The development of a 'house style' can help to generate a consistent look and feel across all designs and ranges. Here is a typical house style for a flat drawing, which works well for presentations in A4–A3 formats, assuming a drawing of about 12–15cm (5–6in) tall for a top item.

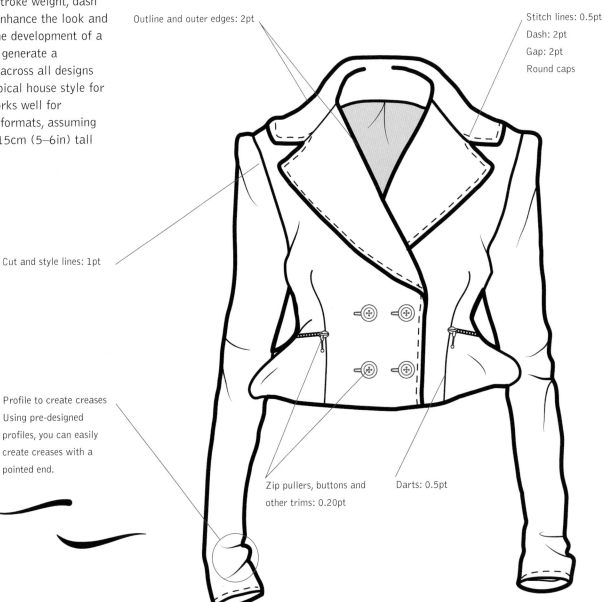

Outline and outer edges: 2pt

Stitch lines: 0.5pt
Dash: 2pt
Gap: 2pt
Round caps

Cut and style lines: 1pt

Profile to create creases
Using pre-designed profiles, you can easily create creases with a pointed end.

Zip pullers, buttons and other trims: 0.20pt

Darts: 0.5pt

Working with colour

Colour, in a fashion context, is crucial since it is often the first thing we unconsciously register when looking at a garment. Colour is also developed first, since it is applied to fabrics, which have long lead times. Colour matching between fabrics with different compositions is also challenging and requires time and expertise.

The management of colour is a perennial problem for designers, with each step from screen to paper to fabric presenting a challenge in controlling and achieving the desired colours. What looks good on screen can be difficult to translate to paper or fabric, and vice versa. When designs are presented on paper, buyers quite often get the wrong idea about the true colour of a finished garment. To resolve this, most fashion houses work with international standard colour systems, such as Pantone®, with dedicated textile colour cards.

To ensure the best results and accuracy, here are a few cardinal rules when it comes to working with colour in a digital to garment context:

- Always start your colour research from real colours (e.g. fabric swatches, cuts, products, printed material etc.).
- Work with a dedicated colour system, such as Pantone® textile, to manage your colours.
- Try, as much as possible, always to present designs accompanied by real colour swatches, to ensure that clients see the actual colours.
- Visualize your selected colours with different lighting contexts (natural light, sun, halogen, incandescent, neon etc: most larger companies use dedicated lightboxes to recreate different lighting environments).
- Try, as much as possible, to view your selected colours on big swatches to really get a feel of how a colour will look on an entire garment.

Illustrator has powerful colour features and works well with both CMYK and RGB colour modes. In this section you can learn how to use colour efficiently and understand the various ways in which you can work and interact with colour, from simple colour fills to fully fledged colour palettes. Let's start the subject with some basic principles about colour and how it works in a digital context.

An example of how the same colour swatch can appear totally different when presented on different media.

How to fill objects with colour

When you draw any object in Illustrator, the default setting is a white fill and a black stroke. Always start by selecting the object you wish to fill in. The fill object square located in the Tools palette represents the selected object's colour status.

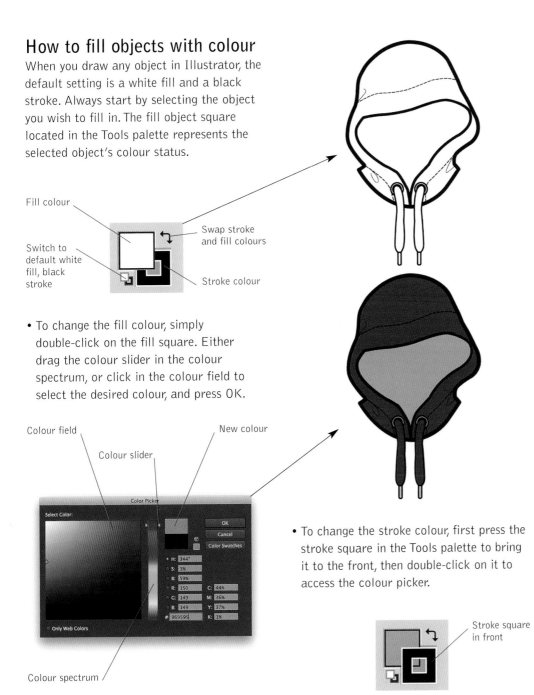

Fill colour

Swap stroke and fill colours

Switch to default white fill, black stroke

Stroke colour

• To change the fill colour, simply double-click on the fill square. Either drag the colour slider in the colour spectrum, or click in the colour field to select the desired colour, and press OK.

Colour field

New colour

Colour slider

Colour spectrum

• To change the stroke colour, first press the stroke square in the Tools palette to bring it to the front, then double-click on it to access the colour picker.

Stroke square in front

• If you select more than one object with different colours of fill or stroke, the fill squares will show a question mark.

The Swatches palette

The Swatches palette (Menu > Window > Swatches) contains a set of default colours from which you can pick. This is a faster way to quickly colour objects. Select the object to fill, then click on a colour swatch.

No-colour swatch

Default swatches

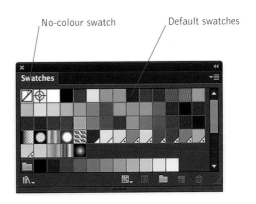

• To assign No Fill or No Stroke, select the no-colour swatch.

No-colour stroke

Using swatch libraries

Illustrator provides several swatch libraries and arranges them into two categories: theme libraries, which are a set of colours based on a theme, and colour books, which are full-colour libraries provided by international brands such as Pantone®. To work with a swatch library, either go to Menu > Window > Swatch Libraries or in the Swatches palette, go to the pop-down menu and select Open Swatch Library.

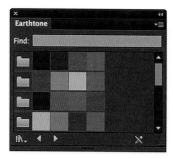

Earth tone colour-themed library.

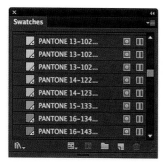

The Pantone fashion swatch library (this library is not available in Illustrator and must be purchased for a small fee).

Let's now design a small colour card with a customized colour group.

- Draw two rectangles to create a colour chip card.

- Type in the text (see page 51) and fill in with colour.

- Move/duplicate more colour chips (use the Align and Distribute functions to space the chips evenly).

- Select all the swatches, and then in the Swatches palette, click on New Colour Group.

- Name the group, and ensure that the Selected Artwork button is ticked; press Selected Artwork and OK.

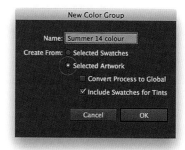

- In the Swatches palette, select the newly created swatch group and in the pop-up menu, go to Save Swatch Library as AI (save in the default swatch folder suggested).

Whenever you need to use this colour card, open it again by going to the Swatches palette's pop-up menu > Open Swatch Library > User Defined.

Working with gradient colour

Illustrator can create fully editable colour gradients; here are the some of the basic gradient skills.

Start by opening a gradient swatch library (Menu > Window > Swatch Libraries > Gradients > Metals).

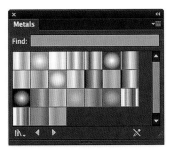

Select the object to fill and apply the gradient like a normal colour.

Customize gradients

Gradients can be fine-tuned to get a more realistic look and feel (for example where a highlight point is, or by changing a colour's composition). Go to Menu > Window > Gradient, and select the object with a gradient fill.

Gradient fill
Choose different preset swatch gradients.

Fade to Black
Super Soft Black Vignette
Green, Yellow, Orange
Purple Radial

Save customized gradient

The same gradient fills customized using the gradient slider

Trims drawn using gradients for a realistic effect.

Gradient slider
To customize gradient fills, select the object and gradient. Drag colours from the Swatches palette into colour wells (bottom). Slide the gradient mixers (top). Remove the colour wells by dragging them away.

Gradient type
Choose between a linear gradient fill and a radial gradient.

Linear

Radial

Pop-up menu
Hide or show the gradient options.

Gradient angle
Set the angle for a more realistic look.

No angle

90°

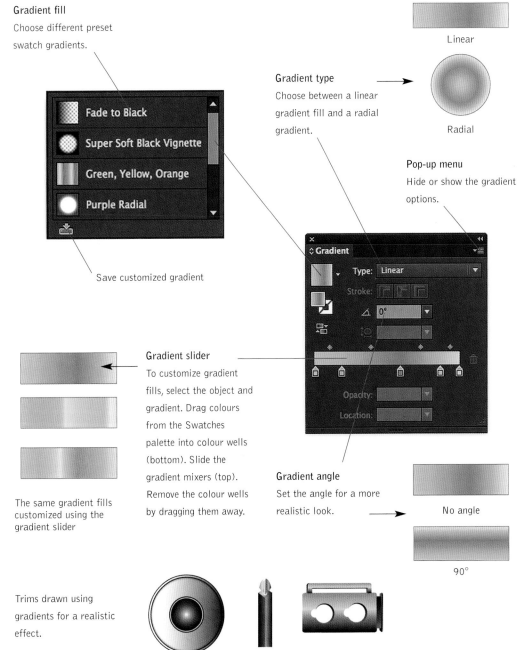

Working with text

Illustrator has a very powerful text editing feature, which is one of the core elements of the application. Typesetting and font design are important skills for a fashion designer to possess. Typefaces are plentiful nowadays and knowing how to select a typeface, set its kerning, leading and tracking, and to then outline it, edit it and transform it will make graphic type look more professional. Type is also used in trims and for branding buttons and neck labels, tapes and other embellishments. Type is also important for page layout on mood boards, line books, portfolios and any other presentation items.

Typography

It was revolutionary when Apple Macintosh included various typefaces on its graphical user interface back in 1984. Since then, desktop publishing has grown into a fully fledged industry and typeface libraries abound, from professional foundries to online amateur ones. Understanding the basic principles of typography will help you to design better logos for trims and prints.

Key typographical aspects:

Lines
Baseline: The line that the type sits on.

Cap line: The top edge of capital letters.

Top line: Where the ascenders of letters such as 'k' or 'h' reach to. For most typefaces, this line is higher than the cap line.

Midline: The height of lower-case letters (excluding ascenders and descenders). Usually measured using the height of the letter 'x'.

Beard line: Where the descenders of letters such as 'p' or 'y' reach to.

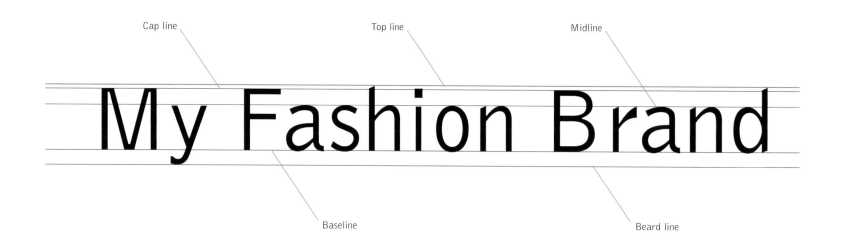

Cap line Top line Midline

My Fashion Brand

Baseline Beard line

Beyond the key typographical aspects, other important points should be assimilated to better understand how to set and fine-tune text properly. All the topics described below can be managed via the Character palette (Menu > Window > Type > Character).

My Fashion Brand
is the Best in Town

a) Type size:

Type size is set in points (pt). You can either choose from the preset sizes in the pop-up menu or input a custom size.

My Fashion

My Fash

My Fa

Text set at different sizes.

c) Leading:

The amount of space between lines of text, measured as the distance between two baselines. Decreasing the leading brings lines closer, making a block of text appear more compacted.

d) Tracking:

Tracking refers to the space between words. It can be loose or tight, and helps with fitting copy into defined areas.

b) Kerning:

The amount of space between two letters. Some letters, such as 'W' or 'T', create uneven spaces at their bases. Kerning helps to balance these uneven areas. To adjust the kerning, select with the type tool between the letters to be kerned (between 'F' and 'a' in this case), then select a value from the menu, or input your own.

Fashion

Fashion

(Above) Word without kerning.
(Below) Kerned word.

85% Cotton
15 % Cashmere
Wash at 30°
Wash dark colours separately
Wash inside out
Do not Bleach
Reshape whilst damp
Do not tumble dry
Cool iron on reverse
do not dry clean

85% Cotton
15 % Cashmere
Wash at 30°
Wash dark colours separately
Wash inside out
Do not Bleach
Reshape whilst damp
Do not tumble dry
Cool iron on reverse
do not dry clean

Working with text in Illustrator

The Mac and Windows PC platforms have a set of typefaces pre-installed on their respective systems and so are accessible in Illustrator. To add more fonts to your operating system, do as follows (Mac OSX):

- Find a font online on a site such as dafont.com (make sure you respect copyright issues).
- Once downloaded, double-click the font's zip folder to unzip it.
- Locate the file with a .ttf or .otf name extension and double-click on it.
- Click on Install Font.
- The font is now installed on the system and Adobe Illustrator will automatically add it to its font list.

Text in Illustrator is always initially displayed as native format, just as in any text-editing software such as MS Word. Illustrator has three methods for creating text: a simple point and click (point type), clicking inside an object (area type), or by typing on a path (type on a path). Typefaces are located in the menu bar under Type > Fonts and also in the control panel (when using the type tool). Fonts can also be accessed in the type window (Menu > Window > Type > Character).

When sharing an Illustrator file that contains non-outlined typefaces, make sure you always send the typeface file along with the Illustrator file.

Text in fully editable native format.

Outlined text.

The type tool (T).

The Character palette.

The Control palette with type display.

The font menu.

Type tools

For simple point and type, select the type tool, put it anywhere on the artboard and point and click. A flashing 'I' will appear; type in the text you require. To change the typeface, go into Type > Font and select a typeface from the menu. To change the size, go into the control panel and select from the pop-up menu. You can also access all these features from the Character palette, as shown on the opposite page.

My Fashion

MY FASHION

My Fashion

To further edit text, you can outline it by selecting Command + Shift + O (or Ctrl + Shift + O for Windows PC), or going to Menu > Type > Create Outline.

MY FASHION

Editing outlined text

Using the white arrow, you can retouch and transform each letter just as you would with any other object. Remember that once outlined, text cannot be retyped. Thus always keep a safe copy of the non-outlined text in case you need it.

1

2

Area type tool

Text can be set inside any object. To type text in an object, first draw an object, then select the area type tool. Note that when a shape is transformed into a text box, it loses its outline frame.

- Draw a colour swatch with two boxes in the text area, one slightly smaller than the other.

- Select the area type tool.

The area type tool.

- Type in the text by clicking on the smaller box.

When the copy is too big for an object it will flow out and a small '+' symbol will appear. Reduce the type size, spacing and kerning in order to fit in the text properly.

Paragraph alignment

Text can be aligned within an object. To do so, select the text and click on different paragraph settings either in the control panel or the Paragraph palette (Menu > Window > Type > Paragraph).

In the swatch below, Paragraph Align Centre was used.

Typing text on a path

Text can be typed on to a path. This feature is very useful in a fashion context, when text is applied on trims or as prints.

- To create text on a path, draw an open path or a closed shape, and select the type on path tool.

 The type on path tool.

- Click on the path and type your text in. Note how the ellipse that is drawn disappears once text is applied to it.

- To adjust the position of the text on a path, select the central handle with the black arrow, and slide to the position you want. You can flip the text on either side of the path by dragging it across the path. You can adjust the path's length by dragging the side brackets in or out.

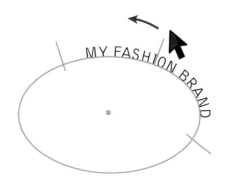

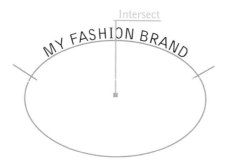

If smart guides are turned on (Menu > View > Smart Guides, or Command + U; Ctrl + U for Windows PC), the text will snap into the path's centre.

Branded button

Here is a quick step-by-step method for creating a branded jeans button.

- Draw two circles, select the type on path tool, click on the smaller circle, type in the words and adjust.

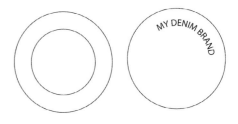

- Draw a third circle that is flush with the text's cap line. Select and highlight the text. Paste it into the newly added circle.

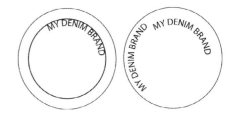

- Grab the central bracket with the black arrow, push inside and position the text. Add any decorative element, adjust the text's position, scale and then group all the elements.

Chapter 2
Flat drawings: building a block library

The previous chapter should have given you a good foundation in the drawing skills needed for Illustrator: now it is time to get into designing garments proper. A flat drawing is the representation of a garment laid on a flat surface. Flat drawings are visually close to garment patterns; they are usually the easiest to draw because, like paper patterns, they have clean lines and use few anchor points. In this chapter we will only focus on drawing outline shapes and key cut lines, in order to create a block library of garment drawings. Like all other drawing types, flat drawings have pros and cons, which are listed below. The most important skill to retain from this chapter is the basic foundation of creating a garment drawing, since this can apply to all other styles of drawing showcased in the following chapters. Always keep in mind how important it is to sketch a good drawing, since it is from this very drawing that a real garment is developed.

Key learning aims

Throughout this book, the key aim is for readers to retain their creativity and learn skills to help achieve speed and efficiency. In the context of flat drawings, the key learning aims we are working towards are:

- To understand the way a flat drawing is 'built'.
- To lay good foundations from which to create a flat drawing.
- To draw simple blocks from which many designs can be spawned.
- To learn skills to save time when working with image reference material.

Pros and cons of flat drawings

Pros
- Quick to draw.
- Closest to a real pattern.
- Easier to edit.

Cons
- Looks wider than it will when worn.
- Can look blocky.
- Can look lifeless.

Working with image reference

It is hard to draw directly on a blank canvas, so to introduce an easier way to design flat drawings, we will get a reference image of a garment laid on a flat surface and use it as a template from which to trace. Illustrator can easily handle bitmap files, which can be used as templates for tracing.

A simple flat drawing of a T-shirt.

Download

The image reference for the drawing (note how the flat drawing has a slimmer body to covey the look and feel when worn, compared to the real T-shirt laid flat).

Structure of a flat drawing block

A flat drawing of a block should always be built with a closed outline to facilitate colouring and so it can easily be transformed into different designs. All the design details are kept on a separate layer to facilitate the transformation into new designs. A flat drawing for a block is usually a very simple design with few anchor points. Here are examples of how a simple T-shirt block can

be swiftly transformed into new blocks ready to be designed.

The way a flat drawing is built and how the anchor points are positioned are very important in order to ensure easy transformation. The three T-shirts have been transformed by using only the direct selection tool, pen tool and the keyboard arrows.

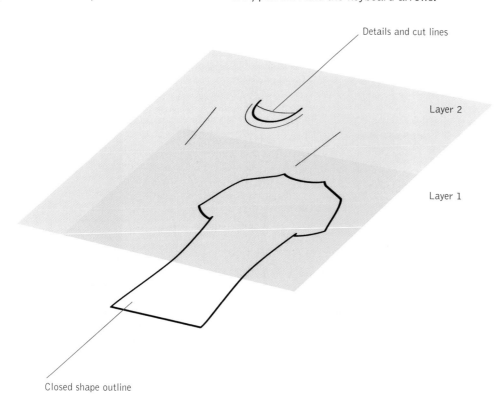

Details and cut lines

Layer 2

Layer 1

Closed shape outline

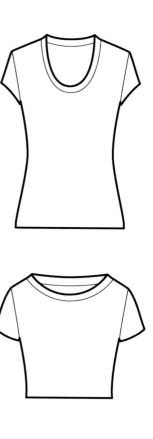

Drawing a T-shirt block

There are three main steps to creating a flat drawing block: draw the outline, edit the outline, and draw the details.

Drawing the outline

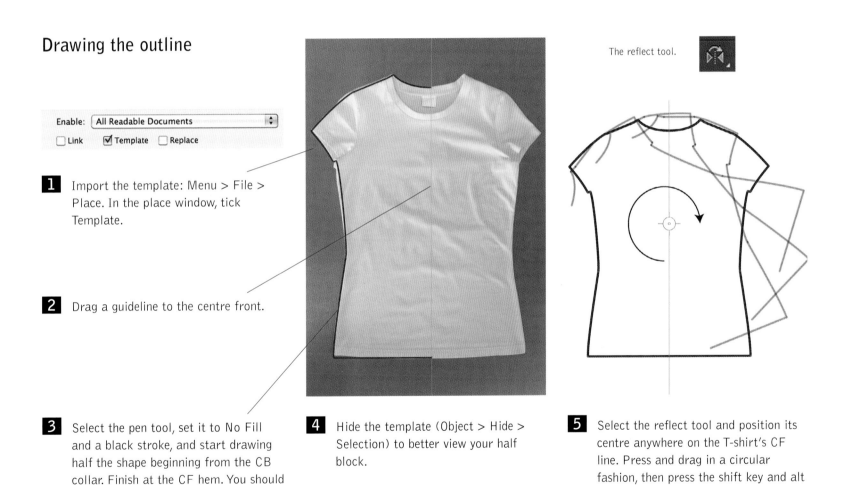

The reflect tool.

1 Import the template: Menu > File > Place. In the place window, tick Template.

2 Drag a guideline to the centre front.

3 Select the pen tool, set it to No Fill and a black stroke, and start drawing half the shape beginning from the CB collar. Finish at the CF hem. You should use no more than ten anchor points.

4 Hide the template (Object > Hide > Selection) to better view your half block.

5 Select the reflect tool and position its centre anywhere on the T-shirt's CF line. Press and drag in a circular fashion, then press the shift key and alt key. Snap the shape into position, and release the mouse/trackpad button first, then the alt and shift keys.

Edit the outline

By editing the shape of the outline, you can achieve better proportions that are closer to what a T-shirt looks like when worn.

1 With the white arrow, select the anchor points to be moved and press the arrow key to move them.

2 With the lasso tool, you can select anchor points in tight corners more precisely.

3 Once finished, reflect the half shape again, and average and join at the CF neck and hem points (see page 39 for detailed average and join techniques).

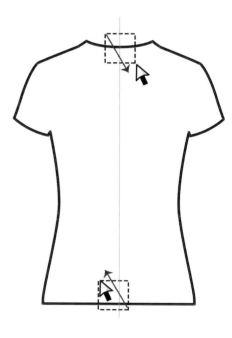

If you use the arrow keys and count the moves you make (e.g. fifteen moves to the right, one up, etc.), you can easily replicate this on the other side of the flat drawing. Alternatively, make the changes on the left side, delete the right side and reflect again.

With the white arrow, select individual anchor points then edit the curves by grabbing the curve handles.

If the shape has a white fill, you will have trouble selecting the CF anchor points unless you come from outside the shape. So it is always good practice to start a press and drag from the outside towards the inside of a shape.

Draw the details

There are many ways to draw details. Here is one technique that works well for simple flat drawing blocks and allows for fast updating.

1 Create a new layer; with the pen tool, draw the sleeve cut line. Mirror/duplicate it using the reflect tool.

2 To create the neckline, select the top part of the outline with the white arrow, copy and paste it in front, and move it down to align with the neckline side mark.

3 For the front collar, with the pen tool, draw half the neck with two anchor points.

5 Cut the overspill path using the scissors tool.

7 Finally, select the entire front view with all details, and press, drag and duplicate. Delete the front 'collar' lines and extend the back neckline to finish the back view. Add colour to the outlined shape.

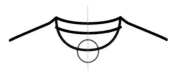

4 Mirror/duplicate the half-collar, then average and join.

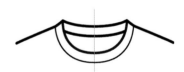

6 Draw the neckline with the pen tool, with two anchor points starting from the side neck. Mirror/duplicate, then average-join.

Delete collar lines

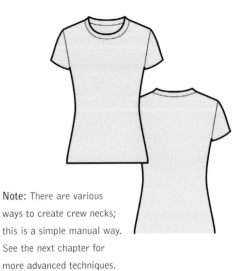

Note: There are various ways to create crew necks; this is a simple manual way. See the next chapter for more advanced techniques.

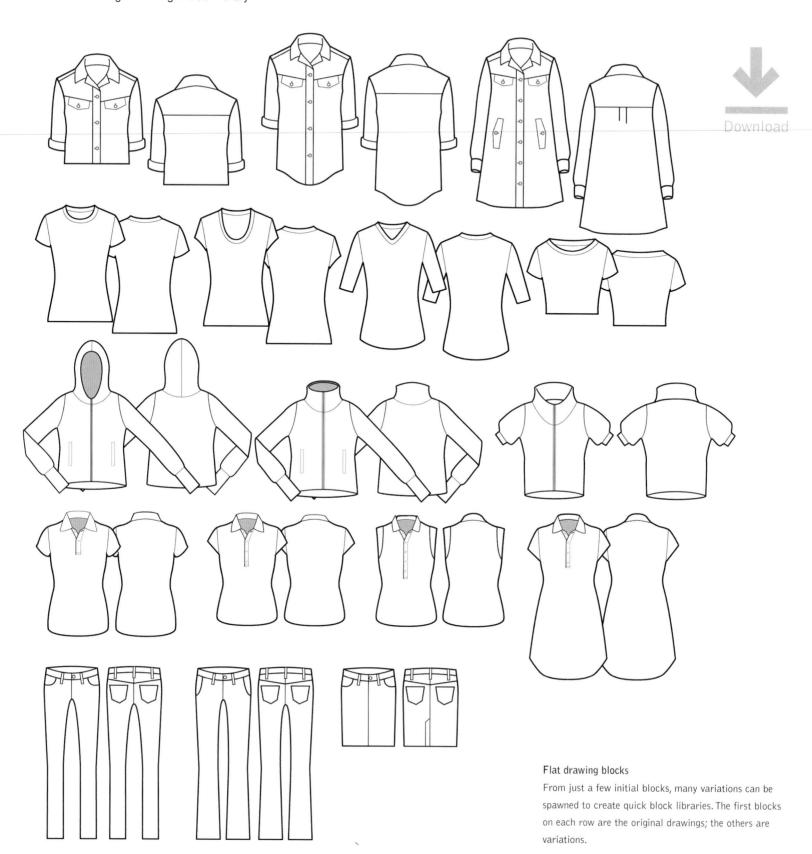

Flat drawing blocks

From just a few initial blocks, many variations can be
spawned to create quick block libraries. The first blocks
on each row are the original drawings; the others are
variations.

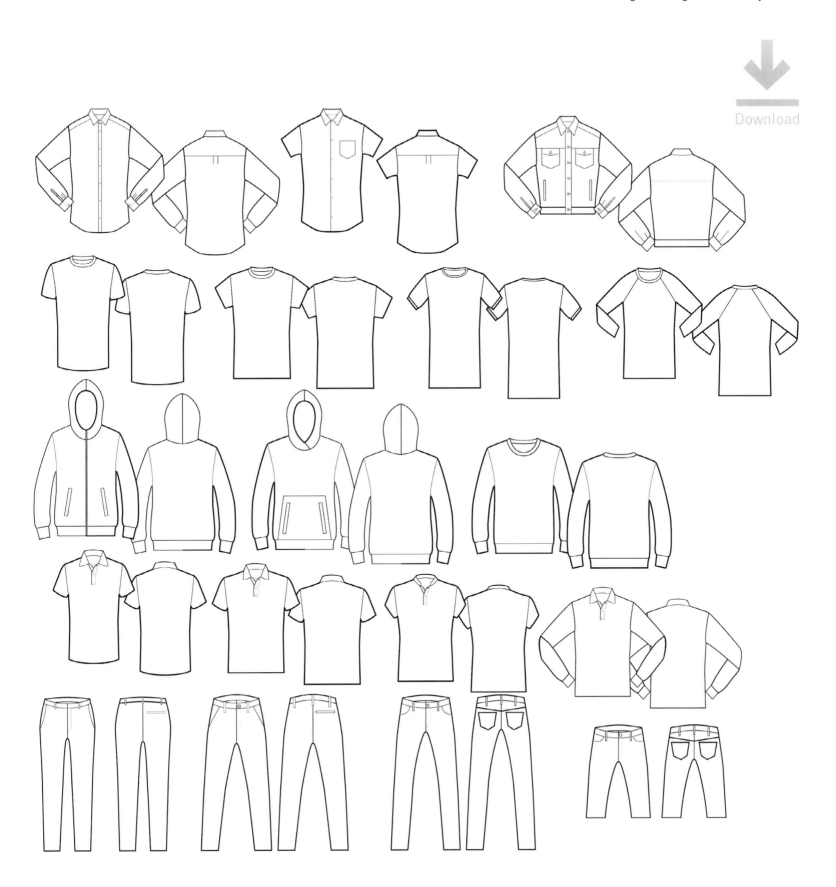

Chapter 3
Flat drawings: basic detailing

This first chapter on detailing focuses on learning basic Illustrator functions. Although seasoned designers use Illustrator's many advanced functions to facilitate the drawing of details, it is important for new users to learn how to draw details from scratch. I encourage readers to develop their own unique style of 'handwriting' and to experiment with how best to represent details on a flat drawing.

At this stage, readers should seek to develop core skills and to nurture their style. Nevertheless, this chapter also helps new users to start understanding how to harness the power of Illustrator. Finally, remember that it is important to create details that can easily be used across many designs, so 'think modular', where details are independent entities.

Key skills
- Create topstitching.
- Draw details accurately.
- Draw from reference images.

Key Illustrator functions
- Dashed lines
- Offset path
- Outline stroke
- Pathfinder
- Symbols (basic level)
- Effects (basic level)

Key learning aims
- To create details from predefined shapes.
- To use simple Illustrator functions to create details.
- To use the simple Pathfinder function to build details.
- To create a trim library.
- To work with image reference material.

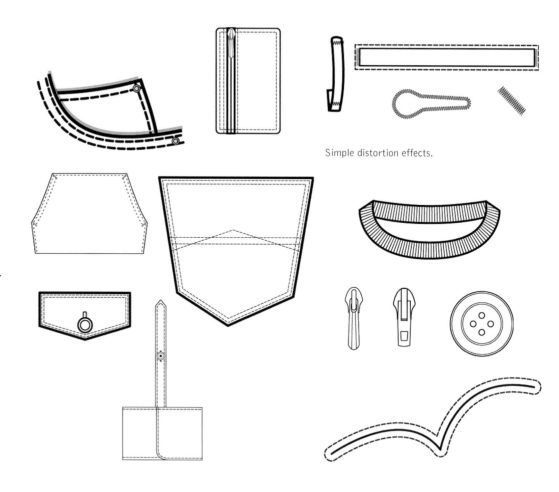

Simple distortion effects.

Examples of details drawn separately from their respective garments.

Simple details using the outline stroke.

Create a line of topstitching

One of the most ubiquitous details on garments is a topstitch line. Here are simple and more advanced techniques to create perfect lines of topstitching.

Create a simple line of topstitching

To create a simple topstitch, start by drawing a line with the pen tool. Select it, then in the Stroke palette, tick Dashed Line.

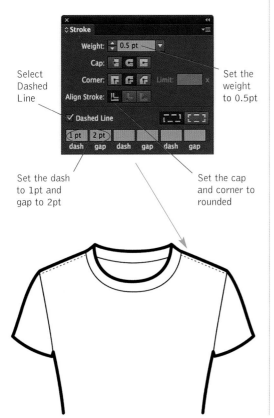

Select Dashed Line

Set the weight to 0.5pt

Set the dash to 1pt and gap to 2pt

Set the cap and corner to rounded

Create parallel lines of topstitching on curved segments

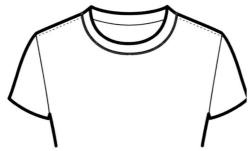

1 With the black arrow, select the segment you want the parallel lines of topstitching to apply to.

2 Go to Menu > Object > Path > Offset Path. In the dialogue box, tick Preview and adjust the offset value to suit your design. Press OK.

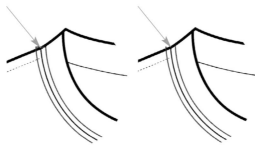

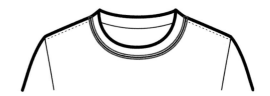

3 With the white arrow, click on the segment that joins the two long segments and press Delete. Repeat with the other joining segment.

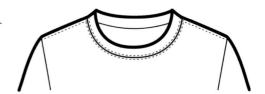

4 Finish by adding a dashed line on the remaining segment.

Create a simple ribbing effect

This simple technique requires the use of the Outline Stroke function, and is best done by drawing the ribbing collar or cuff from scratch and as a separate entity.

1 Start by drawing the back neck collar with a single line. Copy and paste it in front.

2 Give the pasted line a stroke weight of approximately 8pt.

3 Go to Menu > Object > Path > Outline Stroke. This creates a path around the stroke.

4 In the toolbox, swap the fill and stroke colours.

5 Select the inner path with the black arrow.

6 In the Stroke palette, tick the dashed line and input a dash of 0.3pt and a gap of approximately 2pt. Select a weight equal to the one given in Step 2 (8pt in this case).

7 Repeat Steps 1 to 6 to create the front collar. Note the following important points, (a) to (d).

b) After swapping the fill and stroke colours of the outer segment, bring the centre segment to the front.

d) Finish by grouping the entire ribbing collar, making it ready to be part of a detail library. Test the accuracy of your design by placing the collar on a T-shirt block.

a) Make sure the first anchor point snaps to the back-collar anchor point.

c) Fill the outer segment with white and, if necessary, average the anchor points to align the back and front collars.

Create details with the Pathfinder function

Pathfinder is a powerful Illustrator function that creates compound shapes using overlapping paths. Here we punch out holes from an ellipse shape to create a four-hole button.

1 Draw a circle using the ellipse tool. Drag two guides into the circle's centre.

2 Scale down and duplicate the first circle to create grooves in the button. Use the scaling tool and press the shift key and alt key to constrain and duplicate.

3 With the ellipse tool, draw one circle, then use the rotation tool while holding the shift and alt keys to constrain-duplicate.

4 Group the four holes as one entity. Select all and align vertically and horizontally.

5 Ensure that the outermost circle has a colour fill to successfully complete the pathfinder operation.

6 Select both the outermost circle and the four holes. In the Pathfinder palette, click on Minus Front.

7 The new entity created by the pathfinder operation usually comes to the front.

8 If this is the case, send it to the back. (Menu > Object > Arrange > Send to Back).

9 Finish the button by adding threads and grouping it as a single object.

Draw details using a reference image

The best way to draw details accurately is by using a template image. For zip pullers, it is useful to build a library of all the standard pullers.

1 Start by finding a good source image to base your drawing on. Place the image as a template (see page 55).

2 Visually deconstruct and simplify the puller into prime shapes. Draw half of the zip slider's shape with the pen tool. Use the reflect tool to duplicate it.

3 With the rounded rectangle tool, draw the puller's outline.

4 Draw two shapes that make up the hollow parts of the puller. Select both shapes and group them.

5 Select the puller and grouped shapes. In the Pathfinder palette, click on the Minus Front icon.

6 Finish by adding the slider's top part and drawing a groove line around the puller.

7 Group all the elements, making the puller easy to select and move around.

Illustrator effects

Effects in Illustrator enable users to distort and transform any given path. This is a great time-saving function, because rather than drawing a distortion manually, it can be done automatically. The effects menu has plenty of different functions which will be showcased throughout this book; here we start with the most basic ones: distort and transform, and warp.

Distort and transform effects

Under this sub-menu are found several effects. Most – such as roughen, or pucker and bloat – are not very useful for design details, but others are an obvious choice, such as zigzag for quickly drawing bartacks.

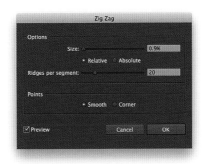

A zigzag effect applied to a segment.

1 To make a zigzag, draw a simple vertical or horizontal line.

2 Select it, go to Menu > Effect > Distort and Transform > Zigzag. Click on Preview, Relative and Smooth, then adjust the size and ridges per segment. Press OK.

Simple details, such as belt loops and jetted pockets, can include the zigzag effect.

Warp effects

Warp effects are great for quickly transforming simple details into pre-designed warp shapes.

A jetted pocket.

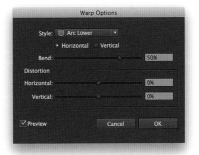

1 Select the object to be transformed, then go to Menu > Effect > Warp. Select any of the required warp shapes.

2 In the window, click on Preview and adjust the parameters to suit the desired transformation.

The same jetted pocket as above, with arc lower warp applied to it.

Create a trim library

In Illustrator, a library is a collection of symbols. Any object created in Illustrator becomes a symbol when added to the symbol panel. When a single symbol is copied several times over a design, each instance of the symbol is linked to the original symbol, saving time and greatly reducing the file size.

1 Start by selecting a trim design.

2 Make sure the symbol panel is open and visible (Menu > Window > Symbols). Drag and drop the selected trim into it.

3 In the dialogue box, simply press OK (this is to save time, as all settings are not relevant for simple symbol usage).

4 Your symbol is now ready to be used. Simply drag it back on to the artboard; note how a symbol is visually defined with cross hairs in its centre.

5 Continue building the library by adding different designs, for example a library of zip pullers.

6 Save the symbol library by selecting Save Symbol Library in the pop-up menu. The file will be automatically saved in the symbol folder and can be opened at any time in the symbol library's pop-up menu (Open Symbol Library > User Defined).

Chapter 4
Freehand drawings: building a block library

A freehand drawing (or sketch) is a hand-drawn representation of a garment, and, as such, is a fast way to represent and communicate a design idea. A freehand drawing is a good balance between a flat drawing and a life drawing: it is neither too rigid and technical nor too lifelike and detailed. Most designers like representing their ideas with freehand drawings because they are fast to do and easily produced. In this chapter we will look at how to develop freehand drawings in various ways and with different techniques, such as preparing a traditional pen and paper freehand sketch for scanning, manually tracing it in Illustrator, and techniques with the live trace tool. To add life to freehand sketches, we will look at how to draw realistic fold and crease lines, and how to sketch good-looking outline silhouettes. The main learning aim in this chapter is to understand garment proportions and how important these are in representing a garment's silhouette and shape accurately.

Key skills
- Trace from a freehand sketch.
- Trace using a reference dummy.
- Work in proportion.
- Draw from reference apparel.

Key Illustrator functions
- Live trace

Key learning aims
- To draw garments proportionally using a reference dummy.
- To draw creases and folds.
- To trace from a hand-drawn sketch.
- To trace from worn apparel.

Pros and cons of freehand drawing
Pros
- A more realistic look and feel.
- A good compromise between look and functionality.
- A better feel for a garment's hanger appeal.

Cons
- More time-consuming to design.
- More time-consuming to update.
- More time spent drawing the block.

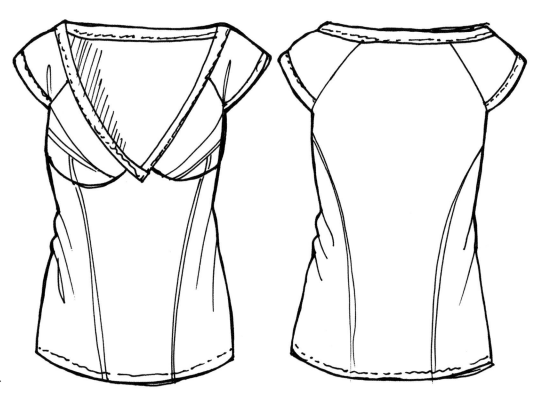

A freehand-drawn top imported and traced in Illustrator.

Preparing a hand-drawn sketch

Many designers still prefer to draw on paper before moving to digital format in Illustrator. This first tutorial explains the best way to prepare hand-drawn sketches so that they can be translated digitally using either manual tracing or live trace.

Preparing a sketch for manual tracing

This technique allows more flexibility, since manual tracing in Illustrator can correct any mistakes such as asymmetric skewing.

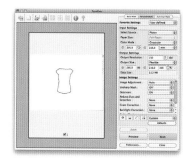

The scanner's driver window.

2 To import the sketch into Illustrator, use a scanner and set the quality to 150 dpi, which is a good compromise between speed and quality.

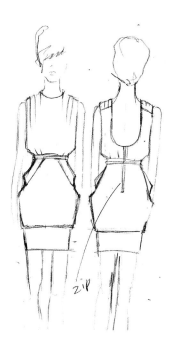

1 Draw your sketch using any preferred media (e.g. pencil, felt-tip or ink pen) on clean white paper. This sketch is by Anna Heinrup.

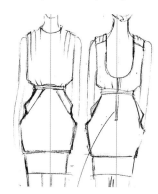

3 Save the scan in JPEG format and place it in Illustrator as a linked template. Drag and drop a guideline on the centre front and centre back. Your sketch is now ready to be traced manually. See opposite page.

Preparing a sketch for live trace

As a first introduction to live trace, we will trace an outline silhouette. Having a simple outline path will enable novice users to understand better how live trace works.

1 Your drawing should be neat and without gaps. Preferably use an ink pen and rub out any pencil marks.

2 Scan as in the previous tutorial, but at 300 dpi in greyscale. In Photoshop, go to Menu > Image > Adjustment > Levels. Move the black and white slider inwards up to the first vertical lines, to make the scan pure black and white. Your sketch is ready to be live traced.

Trace using the pen tool

This first tracing technique is the simplest and very similar to the one done for flat drawings. The main difference is in the anchor point count, which will be greater to facilitate a more lively silhouette.

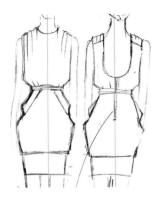

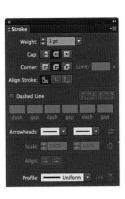

1 Select the pen tool and draw half the outline, starting from the CF neckline. Use a different colour than the drawing to distinguish your tracing from the scan.

2 Reflect and constrain the half shape. Check the accuracy, look and feel by hiding the template layer.

3 Make sure the stroke cap and corner is rounded for a more realistic look and feel.

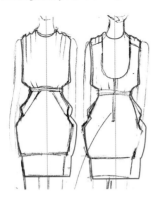

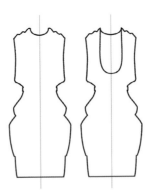

4 Move and copy the front view to the back view template, and retouch or redesign the neckline. Here the back neck is lower, so it should be drawn as a separate line inside the outline shape.

5 Swap the outline colour to black, and hide the template for a last check. Average-join all end points, CF and CB, on the front and back views. The block is now ready for details to be added.

Tracing with a reference dummy

Some seasoned designers like to sketch fast and thus draw their sketches without a reference dummy in order to save time. Yet it is always important to check a drawing's proportions. In this tutorial, we introduce the dummy and how to make the best use of it.

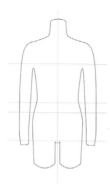

1 There is no need to draw the freehand drawing in detail. The version on the left has sufficient details to be traced in Illustrator. The version on the right is fine, but details such as topstitching can be done faster in Illustrator.

2 Open the dummy's file and place it in as a linked file.

3 Place the scanned flat drawing on top of the dummy.

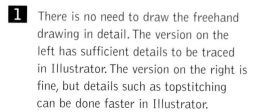

Since the hem is asymmetric, you will need to redraw it before joining both outline sides.

4 Make the drawing transparent and in the Transparency palette, select Multiply (this hides all white areas).

5 Draw half the outline, reflect and duplicate.

6 Toggle off the drawing and dummy layer. Finish by average-joining the end points at CF and CB.

Drawing from image reference

To work really fast, you can do away with drawing a sketch and draw directly from a reference sample for your block or design. Don't forget that reference samples should not be copied one to one to avoid legal issues.

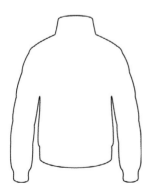

1 Start by taking a picture of the sample, preferably worn by a fitting model or displayed on a mannequin.

2 To get the best look and feel, you can cheat a bit, such as by slimming down the sleeve in this example so that the waist is more visible. This will really help to make the block more attractive. So take time to study the reference image and see where you can better it.

3 Start the tracing with the pen tool, using a colour that stands out to better gauge your tracing as it is being created.

4 Next reflect-duplicate the half outline; hide the image layer before joining both sides to ensure that the outline is attractive.

5 Check that the outline shape you drew fits the back view.

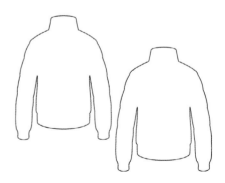

6 Finish by laying out both the back and front views. Remember that if you want to work fast, you can do away with a different back shape (it really depends on the reference garment) and simply duplicate the front view.

Live trace/image trace

Live trace (or image trace in CS6) transforms bitmap images into vector graphics automatically. The key to a good live trace is to master and fine-tune all the various settings found in the tracing options window. Illustrator CS6 has a brand new tracing engine, so we look both at pre-CS6 and CS6 tracing.

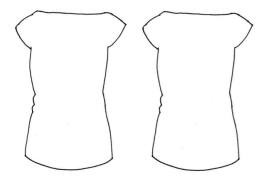

The original scan (left) and the traced version (right). (CS6 sketch art.)

1 Start by placing the scanned drawing into Illustrator (Menu > File > Place).

CS5 (above) and CS6 (below) versions.

2 In the control panel, click on the pop-up menu next to the Live Trace button and select Tracing Options (CS5) or Sketched Art (CS6).

Mode:
To trace freehand sketches, always select black and white.

Tick Fills for best results.

Preview:
Tick to better see how changed parameters affect your sketch.

Path fitting:
Lower values result in a tighter path fitting; higher values result in a looser fitting.

Ignore white:
Prevents white fills around the image frame.

3 The tracing options window for CS5.

4 Press Trace in the tracing options dialogue box, and finish by expanding the tracing (click Expand in the control panel).

5 Image trace in CS6: most settings are similar to previous versions of Illustrator, the main difference being that image trace is now a floating palette rather than a function accessed via the menu.

Chapter 5
Freehand flat drawings: mid-level detailing

This second chapter on detailing looks at three key areas: tracing details (which follows from the previous chapter), colouring techniques, and mid-level Illustrator functions for creating details quickly and accurately. The emphasis is very much on 'thinking modular', breaking down a freehand flat drawing into areas of detail with clear ways to develop them in the most fast and effective way. When you draw a freehand sketch by hand you use one tool – a pen;

when you draw a freehand sketch in Illustrator, you can use many tools and functions. The most important learning aim is to shift a vertical and linear way of thinking (I need to draw every detail by hand) to an attitude of 'What is the best tool to draw this fast, and what will help me to do it most efficiently?' We will also start mixing various functions to achieve more complex details. Readers are also invited to continue building and adding to their details libraries.

Key skills
- Trace details and crease lines.
- Learn mid-level path techniques.
- Learn mid-level fill design.

Key Illustrator functions
- Clipping mask (basics)
- Pathfinder (divide)
- Colouring
- Symbols (symbol sprayer basics)
- Pattern brush

Key learning aims
- To work in a modular way.
- To use a mix of Illustrator functions.
- To understand the structure of freehand drawings.

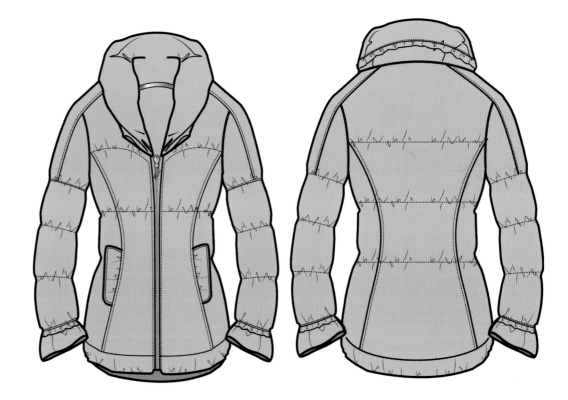

Download

A freehand flat drawing that includes the use of various skills and functions, such as the pattern brush and stroke profiles.

Drawing details: modular method

All details are not equal! To work faster, designers should 'think modular'. Details that are easy to draw can be done manually, but other complicated details should be produced using specific Illustrator functions. It is also important to build detail libraries in order to be able to quickly drag and drop details on to a freehand drawing.

Here is a quick overview of how to design each detail as a separate module.

The collar top is drawn using an outline path and merging it with front top collar line (see page 83, Merge paths to create shapes).

The back and front necklines are drawn manually as an outline shape with the pen tool.

The back and front view are the same outline shape.

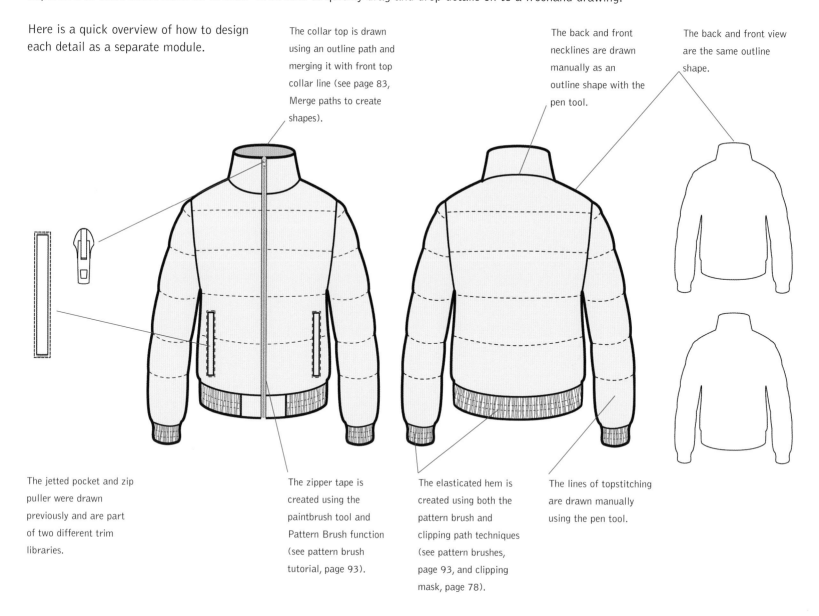

The jetted pocket and zip puller were drawn previously and are part of two different trim libraries.

The zipper tape is created using the paintbrush tool and Pattern Brush function (see pattern brush tutorial, page 93).

The elasticated hem is created using both the pattern brush and clipping path techniques (see pattern brushes, page 93, and clipping mask, page 78).

The lines of topstitching are drawn manually using the pen tool.

Drawing details: stroke profile

Lines drawn in Illustrator so far have been done using the default profile and the cap and corner options. Stroke profiles enable you to apply different profiles to drawn paths. This is a fast and efficient way to reproduce folds and creases. We pick up from the last chapter, where the dress outline was drawn.

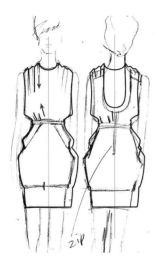

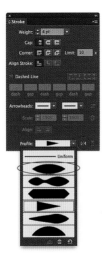

3 For folds coming from the garment outline into the body, select a profile as shown above, which looks as follows on a drawn path (as shown below).

1 With the pen tool, draw the folds and creases on one side, both front and back views. Ensure that paths are always drawn from the outside towards the inside. (Sketch by Anna Heinrup).

2 Select all the drawn crease lines; in the Stroke palette, select a profile.

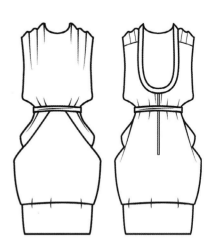

4 If the profile is the wrong way, click the Flip Along button (see step 2).

5 For creases drawn inside the garment, use a profile as shown above, with the resulting stroke line.

6 Adjust the stroke weights, finish the detailing, and then reflect-duplicate all the details. Hide the template to adjust the details if necessary.

Drawing details: mixing pen and pencil tools

So far we have mainly used the pen tool to draw details, which is more accurate than the pencil, but more time-consuming. The pencil tool works faster but can be unnerving to use, even with a good graphics tablet. This tutorial demonstrates how best to maximize both tools' strong points. We pick up from the last chapter, where the trench coat outline was drawn.

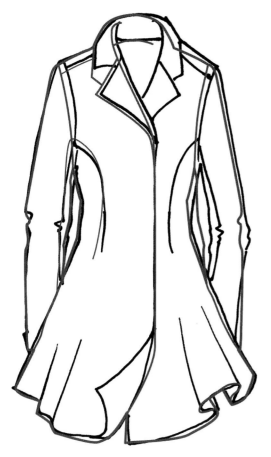

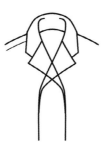

2 To complete collar and CF opening, first reflect-duplicate the elements, then lock the side you wish to keep. Use the scissors to cut away and delete the extra bits.

3 For the belt and pocket details, draw them as separate entities to be saved into a library, as they can be used on other styles or altered.

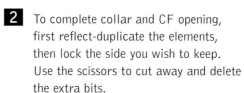

Fold lines with a high smoothness amount (top) and low fidelity (bottom).

1 Start by drawing the cut line details. The pen tool is better suited to do this: the lines will be sharper and define the cutting style better.

4 Draw the crease and fold lines using the pencil tool. As shown in Chapter 1, the pencil tool's fidelity and smoothness can be fine-tuned to achieve the best results.

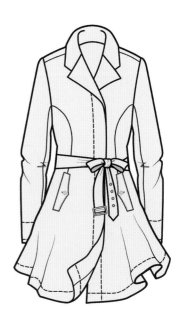

Drawing details: draping, creases and folds

It can be challenging to create realistic draping: quite often, the best way to proceed is to trace a reference image or draw from life if you are skilled at drawing. Most of the freehand drawings showcased here have a regular outline shape, and are very detailed in order to express draped and folded volumes.

The key to a successful draping effect is to constantly check the result of tracing without the reference image while designing it. It is a question of ensuring that the way it looks feels right.

A flowing drape achieved with quick pencil strokes.

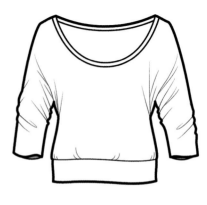

Focus on the sleeves, with different thicknesses to enhance the fold effects.

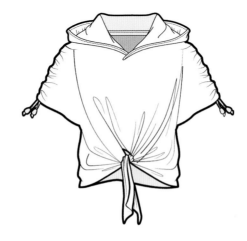

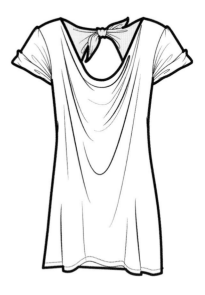

Pay attention to stroke weights: this will give more depth to creases.

This knotted hem was drawn using a reference picture to ensure a realistic look.

The draped neckline was drawn with different profiles and stroke thicknesses.

Clipping mask

Clipping masks can be used in many situations; they are very versatile and can be adapted to solve many design problems. Let's look at how to use clipping masks for ribbings.

Ribbing using a clipping mask

In the previous chapter on detailing, we looked at a simple ribbing, yet this technique has limited scope (perpendicular and parallel shapes). With the added Clipping Mask function, ribbing can be drawn on to any shape. A clipping mask hides the part of a drawn object that lies outside the mask yet remains fully editable. Find a suitable shape to use or download the one shown here.

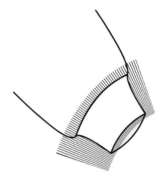

1 The closed shape into which the ribbing goes should have a white fill and a black stroke.

2 Draw a line roughly in the middle of the ribbing shape, making sure it spills out on both sides of the ribbing shape.

3 Copy the ribbing shape and paste it in front, ensuring that it is above the drawn line.

4 Apply a dashed line to the segment with a high stroke amount, so that it spills generously on all sides of the closed ribbing shape.

5 Create the clipping mask by selecting the ribbing line and the ribbing shape, then Menu > Object > Clipping Mask > Make (Command + 7 or Ctrl + 7 for Windows PC). You can easily edit the clipping mask's content by double-clicking on it to enter isolation mode.

Live trace

Live Trace (or Image Trace for CS6 users) can help with design details such as trims. This technique is really useful in helping deliver convincing-looking design details without much effort when you're in a rush.

Creating trims with live trace

We have previously used live trace for simple black-and-white outline tracing. Here we go a step further by tracing an entire bitmap image. This method is the fastest way to develop a trim, yet it needs to be prepared well for best results. A live trace should be better looking than a hand-traced trim, but not so detailed that it stands out. The key to a successful live trace is to break down a trim into what needs to be live traced and what can be done manually.

This part can be traced manually since it is a simple geometric form.

These parts will benefit from a live trace.

1 Select an image, ensuring that it is clear and in as high a resolution as possible. In Photoshop, adjust using curves and levels; try also to knock out the background. Save as a PSD file with layers.

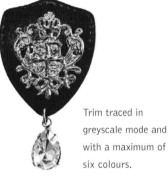

Trim traced in greyscale mode and with a maximum of six colours.

2 Open the image in Illustrator, select it and copy and paste it, then go to the live trace option (Menu > Object > Live Trace > Tracing Options or Image Trace in CS6).

3 Live trace creates a huge number of anchor points, so use the white arrow or lasso tool (after you've expanded the live trace) to select and delete the unwanted anchor points and paths.

4 Redraw the shield using the pen tool.

5 The trim can now be added to a symbol library so that it is easily accessible and will be less memory-hungry. You can also do quick colour variations.

Path operation

Even with the best-laid plans, things can change at any time (especially in fashion!). So here we look at how to adapt a design from a drawing that was intended to be a single colour to a drawing with different-coloured areas.

Preparing a freehand drawing for multiple colouring

This tutorial focuses on multiple colour fills for different areas of a drawing such as an inside view, or panelling, etc. We first showcase two distinctive techniques for achieving the same results: one is time-consuming yet precise, while the other is faster but messier.

Although both patching and pathfinder techniques appear the same on the finished garment, their structure is very different. See page 82 for how to use the pathfinder method.

A freehand flat drawing with a one-colour fill, outline and details (top) and details layer only (below).

A drawing using the patching method to create different fill areas, which is fast to develop but can lack accuracy and become problematic when updating the sketch. See opposite page for how to draw different fill areas using the patching method.

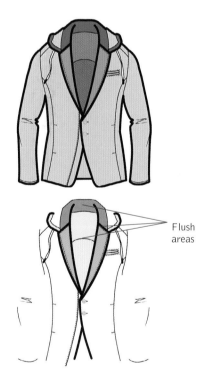

A drawing using the pathfinder method to create different fill areas made from existing paths, which is more time-consuming yet more precise and non-destructive.

Patching technique

As previously introduced, the patching technique enables the fast colouring of different areas within a flat drawing. For successful and trouble-free patching, it's important to know from the start which areas need different colours.

Patching is a simple technique: it basically consists of drawing patches that outline a zone. The patches' overlaps are hidden behind other design elements.

Right: The end result should be like this sketch of a jacket; as such, the drawing should not consist of an outline shape and detail lines, but rather of a series of patches.

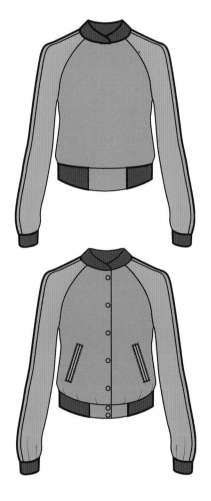

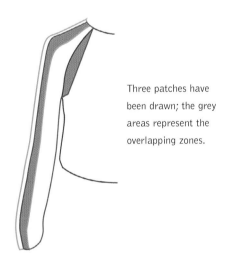

Three patches have been drawn; the grey areas represent the overlapping zones.

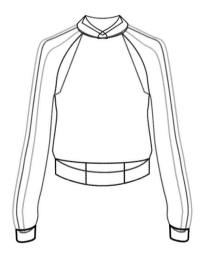

1 Draw the patches one by one as you trace the source image. The patch areas that will be visible should be traced neatly, whereas the hidden parts can be swiftly traced.

2 Reflect and average-join the half shape, and draw the other key details such as collar, cuffs and ribbing. At this stage, keep all details free of fill colour.

3 Fill in each patch area with colour, then adjust the stacking order to ensure that all unwanted patching areas are hidden (e.g. the waistline ribbing is above the body of the jacket, so it should be sent to the back).

4 Finish by adding smaller details such as crease marks, pockets and buttons.

Pathfinder divide technique

The pathfinder function will enable you to easily switch between sketches with one-colour and multiple-colour fills. Unlike the patching technique, the pathfinder divide technique does not require new lines to create a closed shape, since existing lines are used to divide the shape into two separate objects. In this tutorial we design a T-shirt with contrasting sleeves.

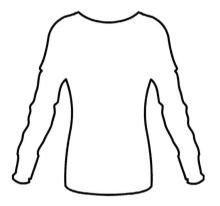

1 Draw a freehand sketch, starting with the outline.

2 Draw one armhole line, ensuring that it spills out on both sides of the outline shape.

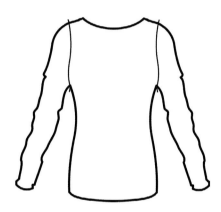

3 Reflect and duplicate the extended armhole cut line.

4 Select the outline and copy and paste it in front, then lock it. Next, select both the outline and one armhole cut line. In the pathfinder window, click on Divide.

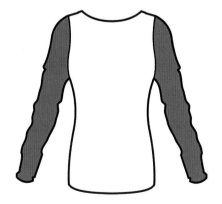

5 Repeat on the other armhole, then ungroup the outline shape and fill in with different colours.

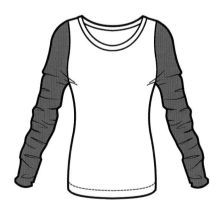

6 Finish by adding all the design details.

Merge paths to create shapes

Starting from an outline shape with drawn details, we will create a closed shape by merging separately drawn paths.

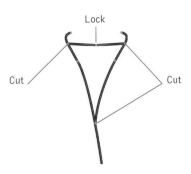

1 This dress needs a separate colour to better express the inside view of the open neckline.

2 With the black arrow, select all the segments needed to create the closed shape, and copy them. Create a new layer above the original layer, lock and hide the original layer, and paste the elements in front.

3 The first operation consists of cutting away the excess bits. Start by locking the paths that do not need trimming, then with the scissors tool, cut and delete the excess bits (you can also use the eraser tool).

4 Next, join the end bits together and with the white arrow, select two end anchor points. Join but DO NOT average.

5 Finish by filling in the new closed shape in the desired colour. You can also transfer the new shape back into the original layer. Give it No Stroke and set it behind the detail lines.

Colour fills

Filling a sketch with colour is an important part of fashion design, as most designs come in various colours (commonly referred to as SKUs, or stock-keeping units). In any busy design studio, colour updating is a daily chore, and being able to do this quickly is a definite bonus.

Using the Recolour Artwork function

This tutorial looks at the Recolour Artwork function, which automates the process of changing colours on a sketch drawing. For best results, create a custom colour library which includes all SKU variations, as shown in Chapter 1.

Control panel

a) The colour card you created in the Swatches palette appears here. Select it.

b) Limit the number of colours needing to be changed (black should stay black as it is the outline colour).

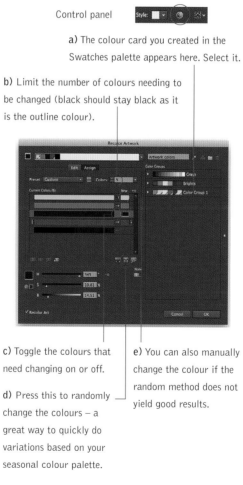

c) Toggle the colours that need changing on or off.

d) Press this to randomly change the colours – a great way to quickly do variations based on your seasonal colour palette.

e) You can also manually change the colour if the random method does not yield good results.

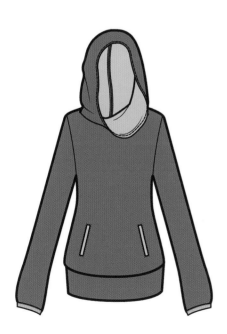

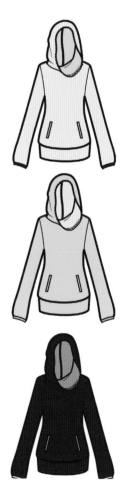

1 Fill in a sketch with colour, and copy and paste the entire sketch.

2 Select the second drawing, then go to Menu > Edit > Edit Colours > Recolour Artwork or in the control panel tick the Recolour Artwork button.

3 Repeat the last step to add another SKU.

Pattern swatches

Illustrator has a very powerful Pattern Fill function, which has been totally revised in CS6 (see pages 12–13). Since pattern design belongs to textile design, we will only look at the basics here; for more in-depth information on pattern design, refer to my book *Digital Fashion Print*.

Let's start with Illustrator's pre-designed pattern swatches and learn how to scale and move them.

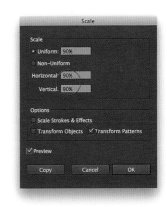

2 If the scale of the swatch is too big, you can change it. Select the outline, double-click on the scale tool, then in the palette, un-tick Scale Strokes and Effects and Objects, input a small decrease such as 90%, and press OK. Directly after that, press Command + D (Ctrl + D for Windows PC). This will reduce the scale by a further 10%.

1 Select the outline shape of the drawing to be filled in, go to the Swatches palette's pop-up menu and select Open Swatch Library > Pattern > Decorative. Click on a swatch that takes your fancy.

3 Carry on until you reach the desired scale for your drawing.

4 From now on, even if you change the pattern, the scale will remain the same.

Pattern with adjustment and Transform Each

You can adjust the position of a pattern within a given shape so that the repeat fits well into the overall design.
To better explain this, we will use a bold pattern that needs adjusting.

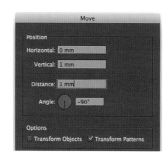

1 Fill in the outline shape with a chosen pattern. Note how some of the stars are not well positioned and how the centre is empty.

2 Select the outline shape containing the pattern, then double-click on the black arrow.

3 Set a small increase in either the horizontal or vertical position, and make sure you un-tick the objects box. Press OK, then Transform Again (Command + D) to adjust further.

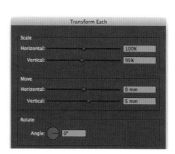

This technique can be useful, but you can also look at page 87 for another way to adjust patterns inside shapes. Transform Each enables users to move, copy and scale objects, making it the perfect tool for creating gradient stripes.

1 Draw a first rectangle, then press Command + Alt + Shift + D (Ctrl + Alt + Shift + D for Windows PC). Set a smaller vertical scale and a small vertical move, and press Copy.

2 Press Transform Again (Command + D) until the stripe thins out totally. This pattern can either be made as a swatch or used in a clipping mask.

Create pattern swatches

Moving on from using pre-designed pattern swatches, this tutorial looks at how to create a simple stripe pattern and rotate it. Rotating a swatch is an important skill, since it enables a designer to represent a printed or yarn-dyed fabric's grain line accurately.

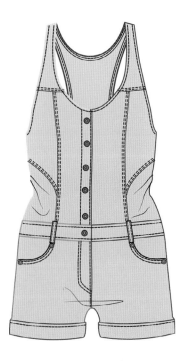

The freehand sketch's fill areas have been divided into several closed objects so that the stripe's grain line can be allocated accordingly.

1 To create the stripe swatch, start by drawing at least two rectangles with different colours on top of each other. Make sure that they are the same width and that there is no gap between them.

2 Drag and drop the rectangle in the Swatches palette.

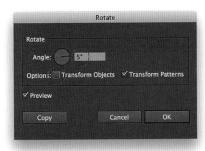

3 Select all the areas on the sketch to be filled in with the swatch, and click on the swatch to fill in. Next, select one shape that needs its grain line adjusting. Double-click on the rotation tool. In the dialogue box, under Angle, type in a small angle increment or decrement (5 or -5). Under Options, un-tick Objects.

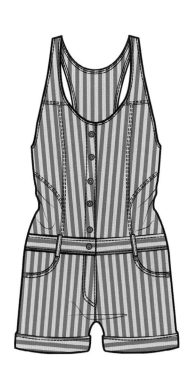

4 To continue the rotation clockwise or anticlockwise, press Command + D (Ctrl + D for Windows PC); keep on doing this until you reach the desired angle (use Command + Z to step back if you go too far). Note: If some areas have straight grain lines (such as the back panel on this garment), you can input a 90° rotation directly in the rotation tool's dialogue box.

Above: The finished design with adjusted grain lines.

Pattern with clipping masks

Some designers prefer to keep control of a pattern by drawing it manually and using a clipping mask to display it in the outline shape. It is also useful to follow this method for a technical design pack that is to be handed over to a developer.

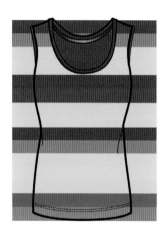

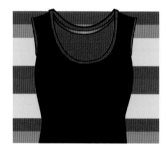

1 Start by drawing a striped design using the rectangle tool. Make it high enough to cover your freehand sketch. Ensure that there are no gaps between the rectangles.

2 Group all the lines into a single object, move the outline sketch on top of the striped block and make sure it fits.

3 Copy the outline shape and paste it in front. Invert the fill and stroke so you end up with a black fill and no stroke.

4 Select both the stripes and the outline, do a clipping path (Command + 7 or Ctrl + 7 for Windows PC). Note: The advantage of this technique is to be able to swiftly change a single colour within the clipping mask. To do so, double-click on the stripes to enter isolation mode, then select the stripe to change and apply a new colour.

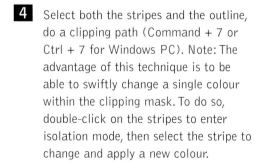

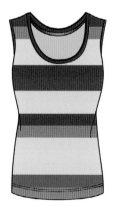

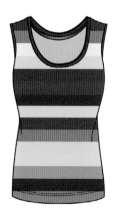

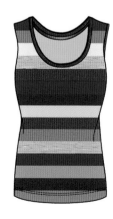

Pattern swatches with bitmap images

The last technique showcased here for colour fills involves working with bitmap images. This technique enables designers to simulate cloth structure and weave or all-over digital prints. This first tutorial on bitmap images fills introduces the basics; see Chapter 7 for a more advanced tutorial.

The trousers have an over-scaled pattern fill: it must be adjusted.

The same drawing with an adjusted pattern tile.

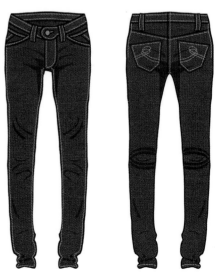

1 Start by sourcing a bitmap image, making sure that the quality is good and that it is evenly lit. As this image will be used as a tile, which will be repeated all over the shape fill, make sure the edges are even. You will need to use Photoshop to retouch and adjust the edges (for more details on how to do this, refer to my book *Digital Fashion Illustration*).

2 Drag and drop the image in the Swatches palette. Select the outline shape and fill it with the image swatch. Ensure that the tile repeat works well: zoom in close up to check, or print it out on paper.

3 Like any other swatch, you can scale, rotate and adjust the position of the pattern fill. For fabric texture, proportion is important, yet most detail can be lost when being too accurate with proportion. So generally try to make the weave a little bit bigger than in reality to capture all the details.

Symbols

We have already looked at how to create trim libraries using symbols; we now move on to use the symbol sprayer, which is one of the many tools associated with symbols.

Working with the symbol sprayer

The symbol sprayer acts as a spray can and lays symbols on the artboard, and it can be highly customized or used with the default set-up. For the best results, use a graphics tablet.

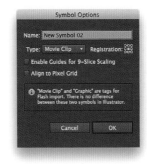

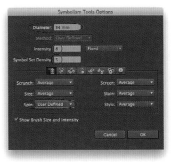

1 If you already have a symbol, select it in the Symbol palette and go to Step 3.

2 If you create a new symbol, drag and drop it into the Symbol palette. Press OK.

The sprayer tool.

3 Double-click the symbol sprayer tool in the toolbox.

4 In Symbolism Tools Options, set the diameter of the sprayer, the intensity and density depending on the kind of result you want to achieve. If you want the symbols to be rotated in different positions, select User Defined on Spin. Press OK.

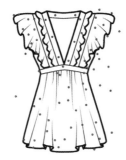

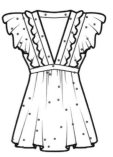

5 Test out different settings by spraying the symbols on a free area.

6 Apply the symbol all over the drawing, and don't worry about spills.

7 Finish by using a clipping mask made with the sketch's outline.

Working with symbol tools

Other tools can be used in conjunction with symbols to further alter the way symbols are laid out on the artboard. Symbol shifter, symbol scruncher, symbol sizer and symbol spinner tools can modify a sprayed set of symbols.

For all of these four tools, the method is the same: start by spraying the symbols, then select one of the symbol modifier tools and press and drag on the symbols to change their position, scale or rotation. Each tool can be customized.

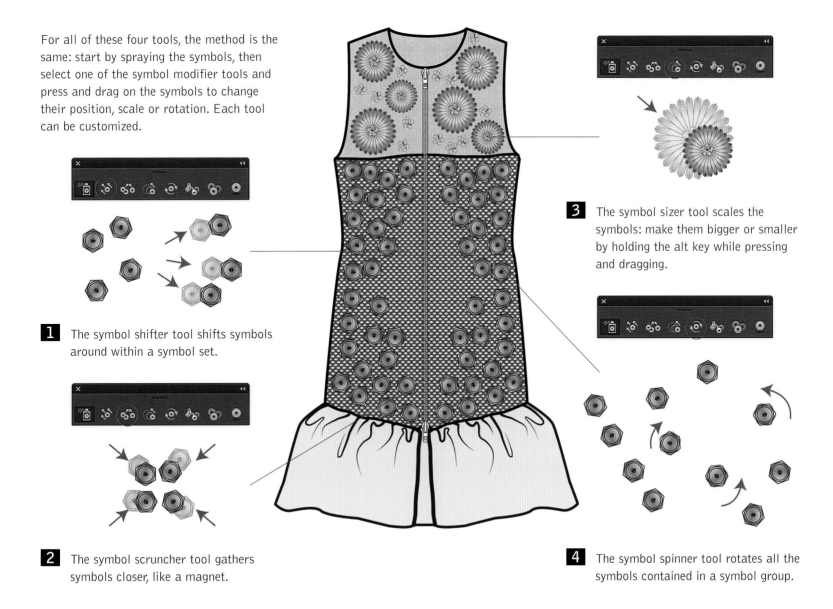

1 The symbol shifter tool shifts symbols around within a symbol set.

2 The symbol scruncher tool gathers symbols closer, like a magnet.

3 The symbol sizer tool scales the symbols: make them bigger or smaller by holding the alt key while pressing and dragging.

4 The symbol spinner tool rotates all the symbols contained in a symbol group.

Editing symbols

Symbols have one crucial advantage: when they are edited or altered, all the instances on the artboard are also updated. This makes the updating of any design a much quicker affair. Symbols can also be 'expanded', which transforms them into regular vector objects. This can be useful for fine-tuning editing but has the disadvantage of cancelling any symbol-editing capabilities.

Edit symbols

A symbol and
its instances.

1 In the Symbol palette, double-click on the symbol to be edited. This will open the isolation mode.

2 In isolation mode, edit the symbol as desired. Exit isolation mode.

Replace symbols

Above: A sprayed set of symbols.
Below: The same symbol set expanded.

1 If the symbols to be replaced are in a set (several symbols sprayed at once), first select the set and expand it (Menu > Object > Expand), then press OK.

2 With the expanded symbols still selected, go to the control panel and click on the pop-up Replace menu.

3 Finally, you can also break the link with the symbol to transform it as a regular object. For this, select the symbol and then go to the control panel and click on Break Link.

This marks the end of the mid-level symbols tutorial. In Chapter 7, more advanced symbol tutorials can be found.

Pattern brushes

The pattern brush is an invaluable, time-saving Illustrator function that can generate great-looking design details when used properly. They might take a bit of time to design, but in the long run will save invaluable time.

Introduction to pattern brushes

Pattern brushes are mostly used to draw details that require repetitive patterns, such as topstitching, zips, creases and folds, etc. Many other design details can be envisaged; only a lack of creativity will limit a designer who is dreaming up new pattern brushes.

Pattern brushes work by painting a pattern made of individual tiles along a path. Pattern brushes can be applied on any path or painted using the brush tool. Pattern brushes adapt and stretch to a given path, which is what makes them so compelling to use.

Left repeat edge Right repeat edge

Top: The outermost left and right edges of the tile form the repeat sequence.
Bottom: The pattern brush adapts to the curve and repeats along a path.

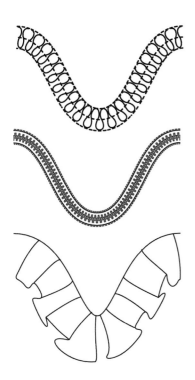

Three different pattern brushes applied on the same path.

The most difficult part when creating advanced pattern brushes is to successfully draw the repeat edges so that the repeat is seamless.

Using a no-fill, no-stroke rectangle which is sent to the back can help to delimit the repeat edges of complex pattern brushes.

When designing a repeat tile for a pattern brush, always keep it in mind to draw the smallest possible repeat sequence in order to save time. Understanding how to get away with the smallest repeat sequence is a skill. The best way to practise this skill is by first observing how a stitch, zip or crease can be broken down to its smallest common denominator.

No fill
No stroke box
Sent to back

Twin-needle topstitch

Teeth zip

Flatlock stitch

Crease and stitch

Create a basic pattern brush

From this tutorial, any simple pattern brush can be designed. Refer to the pattern brush library at the end of the book to see more basic pattern brushes.

1 Draw the smallest possible horizontal repeat that you can get away with. Use vertical guides to help you draw the pattern tile accurately.

2 Make sure that the end points on the left align horizontally with the ones on the right. Select, with the white arrow, both left and right end points and average them (Object > Path > Average > Horizontal).

3 Make sure that the end points align vertically on the left and right sides (Object > Path > Average > Vertical).

4 Select the artwork with the black arrow, and drag and drop it in the Brush palette.

5 Select Pattern Brush.

6 For a basic brush, there is no need to set anything – just press OK.

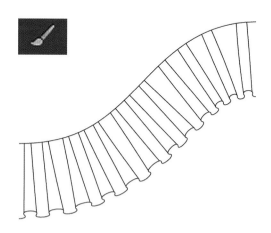

7 Select the paintbrush in the toolbox and draw a curved line to test the brush out. You can also apply a brush to any path, but avoid tight corners or deep curves.

Pattern brush editing

There are many ways that pattern brushes can be edited – for example, they can have different stroke weights, have their colours changed, or be updated with new designs. This editability enables pattern brushes to adapt easily and resolve most design problems.

Edit a pattern brush's weight

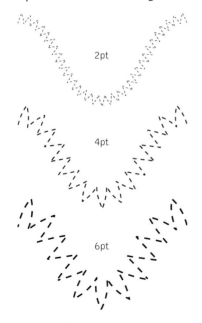

Simply select the brush path and change the weight as you would do with any other object. Note that brushes are quite sensitive to weight change, so avoid big increments.

Edit a pattern brush's colour

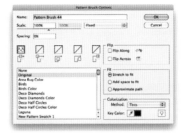

1 To change the colour of a pattern brush easily, you will first need to go to Pattern Brush Options (double-click on the brush instance in the Brush palette). Select Tints under the Colourize pop-up menu.

2 Press OK and then in the second dialogue box, press Apply to Strokes.

3 Finally, select the brush stroke on the artboard and change its colour in the Colour palette.

Edit pattern brushes

When designing pattern brushes, it quite often happens that the brush repeat does not work well or that the look and feel is not right once applied to a path. When faced with this situation, you can easily edit the brush.

1 Edit the original artwork with which a brush was created (here we give the topstitching round caps and corners).

2 Select the artwork, and drag and drop it into the brush well (where the previous design is) while pressing the alt key.

3 Press OK in the first window and then Apply to Stroke in the dialogue box. This will automatically update instances of brushes on the artboard.

Fine-tuning brushes

So far we have passed over the pattern brush options dialogue box, but now let's look in more detail at how to fine-tune pattern brushes and how these options can greatly affect a pattern brush.

Let's start with a simple brush design (saddle stitch and blanket stitch), which suits our needs for this tutorial.

1 Draw the brush tile as shown, and drop it into the brush palette.

2 In the Pattern Brush Options window, adjust the settings as shown here.

Spacing. This enables spacing between each instance of the brush tile.

0% spacing

50% spacing

With a graphics tablet you can vary the brush width based on pressure.

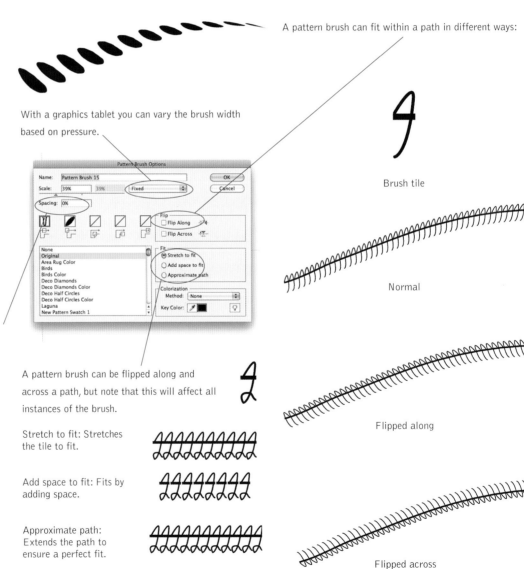

A pattern brush can fit within a path in different ways:

Brush tile

Normal

Flipped along

Flipped across

A pattern brush can be flipped along and across a path, but note that this will affect all instances of the brush.

Stretch to fit: Stretches the tile to fit.

Add space to fit: Fits by adding space.

Approximate path: Extends the path to ensure a perfect fit.

Using a clipping path

Pattern brushes can be used with a clipping mask, which is very useful when designers want a neatly finished look or when a pattern brush is set within an uneven path.

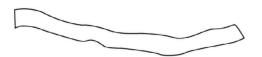

1 Draw or select a closed shape in which the pattern brush should be set. Give it a white fill and black stroke.

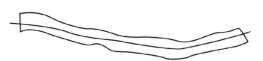

2 Draw a path in the middle of the closed shape on which the pattern brush will be applied; make sure it spills over on the left and right sides.

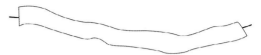

3 Select the closed shape, copy and paste it in front, and take off the black stroke. Ensure that the pasted shape is on top of the path line (bring it to the front if necessary).

4 Select the path line and apply a pattern brush instance to it.

5 Select the pasted shape and brush path, and create a clipping mask (Command + 7 or Ctrl + 7 for Windows PC).

6 Check the look and feel and, if necessary, adjust the brush's path by double-clicking on it to enter isolation mode.

7 Use the white arrow to adjust the path or retouch it with the pencil tool.

Multiple parts brushes

Pattern brushes can have up to five elements representing the different sections of a brush. So far we have only created brushes with the default main body part; now we look at how to create other parts.

This is an example of original artwork made with a three-part pattern brush. Note how the body, start and end parts are laid out.

1 Start by designing the main part (zip teeth) as you have done on previous brushes. Note that you cannot use a bitmap image or gradient in a pattern brush.

2 Do the next part, and ensure that it is aligned with the main part (this is important to ensure that both parts are flush).

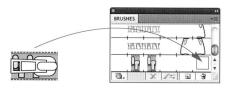

The same brush, with ends neatly stretching to adapt to the curve of a path.

3 Finish the brush design with the other end of the zip, again making sure all elements are flush.

4 Drop the main part brush into the Brush palette as you would do with any other pattern brush. Select the right part, and drag and drop it in the Brush palette aiming for the well on the far right while pressing the alt key. Press OK in the first dialogue and Apply to Stroke in the second.

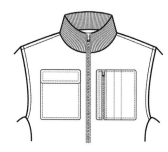

5 Do the same thing with the other end of the brush, but this time drop it in the well to the left of the previous one.

6 The pattern brush is ready to be used on paths.

Chapter 6
Life drawing: building a block library

The third and final block type is the life drawing sketch, which, as its name implies, represents as closely as possible real-life apparel. This type of drawing has been more favoured in recent years due in part to advances in digital technology, making the fast rendering of a life drawing possible with powerful computers. Yet, on the downside, life drawings are usually more time-consuming to produce, are memory- and size-hungry, and are more problematic to update.

Nevertheless, since these drawings have become more prevalent, new techniques and tools have appeared that allow life drawings to be updated more quickly. Interestingly, this kind of drawing is the closest to the way that designers would sketch a life drawing with a pen and paper before computers existed. At last digital drawing methods now allow users to make intuitive sketches, and true drawing skills can be displayed on a computer as naturally as with a pen on paper.

Key skills
- Trace from life.
- Trace from a freehand sketch.
- Draw from a reference image.
- Make a digital drawing.

Key Illustrator functions
Advanced live trace
Virtual pencil and eraser
Width tool

Key learning aims
- To create life in a flat garment.
- To draw creases and folds.
- To gain advanced tracing and life-drawing skills.
- To understand digital drawing.

Life drawing pros and cons
Pros
- Realistic look and feel.
- Good for the rendering of creases, folds etc.
- Great for getting a feel for what a real garment will look like.
- The most intuitive way to draw.

Cons
- Can be time-consuming to design.
- Can be difficult to update.

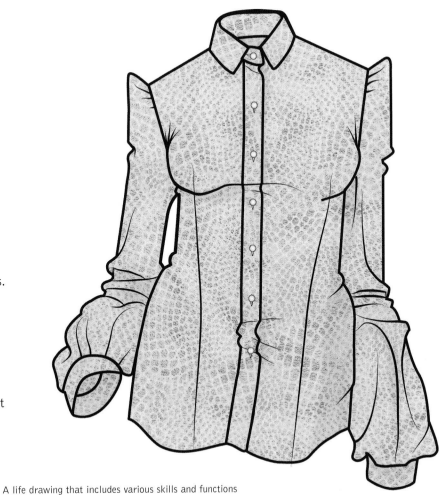

A life drawing that includes various skills and functions which are presented in this and the following chapter.

Trace from life

With garment sketches done in a life-drawing style, you need a good level of drawing skill. It is true that digital media is more tolerant of lower skill levels, but a designer with less drawing experience will always need more time to achieve a good-looking life drawing.

Observe and draw

The key to a good life drawing is to observe a garment as it is being worn and to draw its outline silhouette. If you do not have the luxury of a model posing for you, use reference images, but really try to avoid tracing!

Take time to focus on key details: it is most important to make the creases, folds or draping look and feel realistic. Experiment with different cloth weights, draping and texture to really understand how they interact with the body and gravity. Try to work with different mediums to see which one suits your style of drawing best.

Look at a garment as a whole and observe which part of it makes it come alive when worn, or which part helps to define the silhouette.

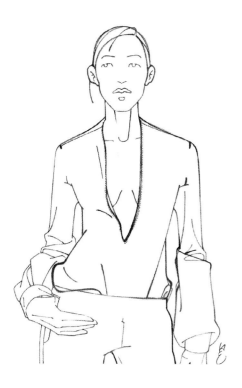

A clean, pencilled, black-and-white illustration of a shirt, with attention to crease details. (Nick F. Cerutti)

Trace from a life-drawn sketch

In the drawing foundation in Chapter 1, we looked at how to use the pencil tool at a basic level. We now move forward to trace life-drawn sketches using the pencil tool at a more advanced level.

The pencil tool is notoriously difficult to fine-tune in Illustrator: it is either too sensitive or too streamlined. So a good measure of old-fashioned trial and error is required here. I recommend going back to page 34, where all the details of the pencil tool's options are displayed, before starting this tutorial.

1 Begin by placing the drawn sketch on your artboard. Either lock it or place it as a template.

2 Using the pencil tool with tried and tested settings (make sure Edit Select Paths is ticked in the pencil options), draw a small portion of the sketch's outline.

3 Draw the second portion, ensuring that it connects with the first one. This can be quite frustrating, so try again or change the Within Pixel value.

4 Go around the whole outline in the same way and close the shape (you can either do it by pressing the alt key or use the white arrow to average and join the shape). Use Smooth and the pencil tool if needed to retouch the outline shape.

Of course, at this stage it seems pointless to retrace a drawing already made with pen and paper, yet the point here is to practise drawing life directly in a digital format, and the next natural step will be to draw without a template – try this if you feel confident.

Trace from a reference image

As in the topic on designing freehand drawing blocks in Chapter 4, here we revisit the technique of using a reference image, but this time with a life-drawing style. The other main difference is that rather than using the pen, we will use the pencil tool to further build freehand digital drawing skills.

1 Start by selecting a suitable reference image of a garment or, even better, by taking a picture of a reference garment, which should be set to feel alive rather than flat and lifeless. Ensure that the background is a different colour from the garment.

2 Place and lock the image, create a new layer to trace, and select the pencil tool with adapted options for a better tracing experience. Start tracing the outline, drawing small segments at a time.

3 Remember you can always retrace a segment if it is not satisfactory by drawing on top of the previous segment of outline.

4 Connect the first segment with a new one, making sure they connect (start close enough to the first segment to connect).

5 End the outline tracing by following the same technique of drawing small segments at a time. Use the smoothing tool and the white arrow to fine-tune; the convert anchor point tool is also useful, since too often the pencil has difficulties with sharp corners.

Live trace an image outline

Live trace can be used to vectorize apparel outlines. This technique is fast and efficient, but needs good preparation to ensure a smooth workflow.

1 Set the garment you wish to vectorize on a light background. For best results, select a dark-coloured garment if possible. Display the garment in such a way as to make it look lively, with a well-defined silhouette. It should be without shadows.

2 Open the image in Photoshop and go to Menu > Image > Mode > Greyscale. Then go to Menu > Layer > New Adjustment Layer > Levels. In the Adjustment palette, slide the black toggle to the right and the white to the left until the image becomes pure black and white. But make sure you do not compromise the garment's outline.

3 Save and close the file. Open and select it in Illustrator. Select live trace (CS5) or image trace (CS6).

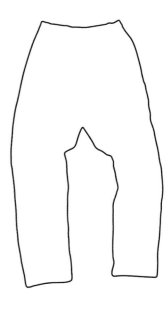

4 In the tracing options, select as shown above right (black and white mode with blur; Trace Settings: Stroke, Ignore White).

5 Trace and expand the image, then give it a regular stroke weight (1–2pt). If necessary, retouch the segment parts that do not look appealing with the pencil tool.

Stroke width tool

The width tool allows you to design different stroke widths within a path. With this tool, you can give a more natural effect to a garment's silhouette by having thicker and thinner stroke widths in relevant positions (for example in crease areas).

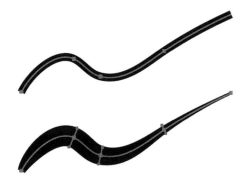

The stroke width tool.

An illustration of how the width tool affects a segment's stroke. Each anchor point can have a custom stroke width assigned to it.

1 Start by selecting a silhouette to which you can apply different stroke widths. Ensure that it has a stroke width of at least 2pt. Select the stroke width tool.

2 Point towards an anchor point that requires a width change, and press and drag either outwards or inwards to change the width.

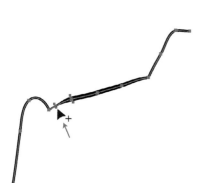

3 You can add a stroke width anywhere on the segment: simply point to the segment and press and drag outwards or inwards. This will automatically add an anchor point.

4 To work faster, select the outline shape and apply a profile in the Stroke palette, then adjust it with the width tool.

An outline shape with a predefined profile (shown in Step 4), retouched with the stroke width tool.

Digital drawing

We can now explore the possibilities of drawing on the computer in the same way that designers have always drawn with pen and paper. Advanced graphics tablets, faster processors and highly evolved applications have all contributed to a more realistic drawing experience.

This tutorial focuses on how to get attuned to drawing outline shapes digitally using only the pencil and eraser tools.

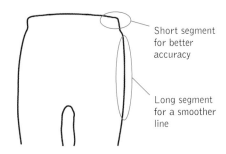

Short segment for better accuracy

Long segment for a smoother line

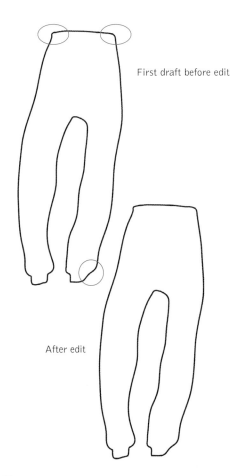

First draft before edit

After edit

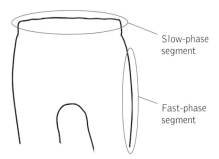

Slow-phase segment

Fast-phase segment

1 The best approach is to first find the scale you prefer to draw at. So experiment by drawing quick outlines at different scales.

2 The pencil's tolerance is based on segment length, so experiment with drawing different segment lengths or portions of the outline to get the best look and feel (not too smooth and not too scribbly).

3 Vary your drawing speed: the faster you draw, the fewer anchor points will be laid; the slower you draw, the more anchor points will be added.

4 Once a decent full silhouette has emerged, you can start editing the path using either the pencil tool to redraw segment parts, the smoothing tool to smooth out bumps, or the eraser to shave off parts of the outline.

Life drawing showcase

Here are a few life drawings including all the details to inspire
you to take on the challenges of the next chapter.

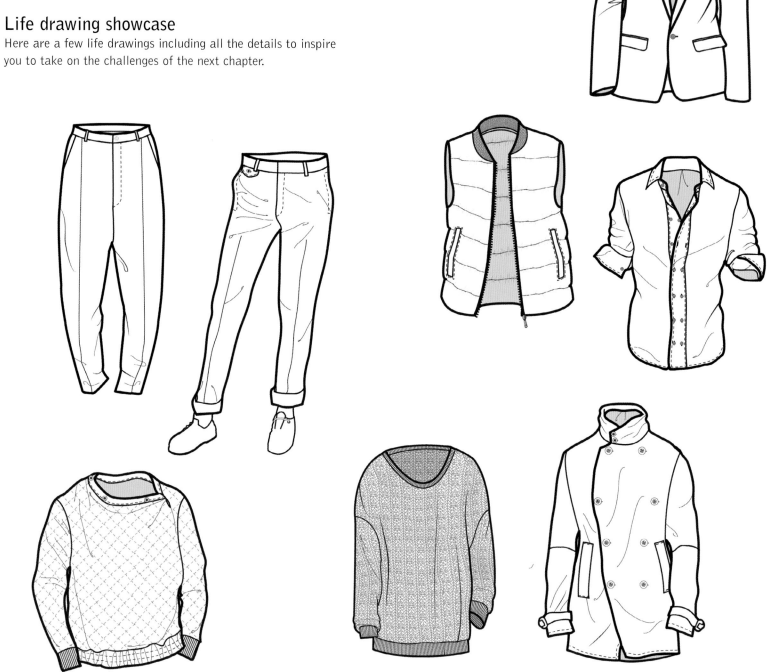

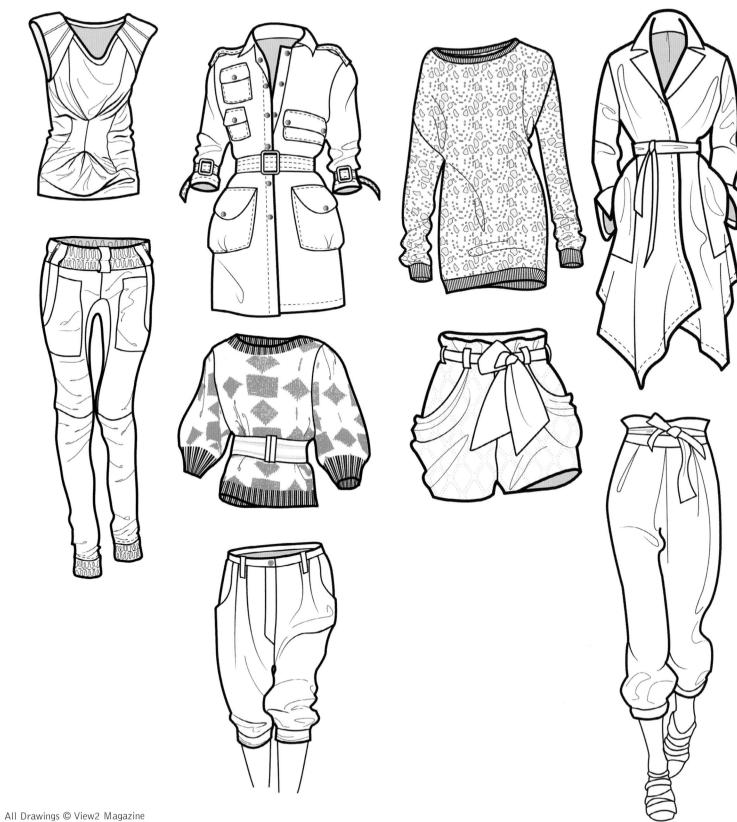

Chapter 7
Life drawing: Advanced detailing

This third and final chapter on detailing looks at the most advanced features on Illustrator, which can help to make fashion drawings look as realistic as possible. Although based on life-drawing silhouettes, this chapter can also be used for freehand drawings. It rounds up and pushes to the limit all the skills, tools and functions learned earlier. We focus on rendering garments realistically so that a drawing replicates, as closely as possible, the real product. Gradient meshes, blur shadings, blendings, 3-D effects and the use of bitmap images are all covered here. Yet highly detailed drawings are not the only story: as always, we also cover techniques for working faster and more efficiently.

Key skills
- Trace details and crease lines.
- Learn advanced-level path techniques.
- Pursue advanced-level surface design.
- Understand appearances.
- Apply effects and blending modes.

Key Illustrator functions
- Blending modes and transparency
- Live paint
- Effects 3-D
- Effects warp
- Effects PS filters
- Appearances
- Graphic styles
- Draw Inside function
- Blend tool
- Shape builder tool
- Gradient meshes
- Envelope distort: mesh and warps
- Shading
- Working with bitmap images (advanced)
- Symbols (advanced symbol colouring)
- Art, bristle and scatter brushes

Key learning aims
- To make realistic drawings using all available effects.
- To use advanced Illustrator functions.

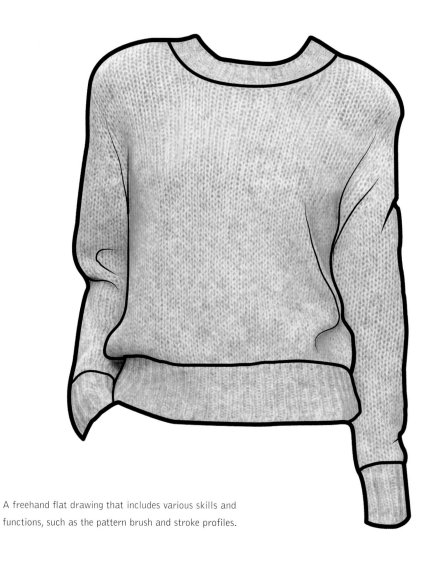

A freehand flat drawing that includes various skills and functions, such as the pattern brush and stroke profiles.

Advanced details overview

To create realistic-looking drawings quickly, we need all the help we can get from Illustrator's tools and functions. A drawing with shading, gradients and surface effects can be complex to produce, yet the functions and tools highlighted here will help to deliver fashion drawings that are easy to develop, highly editable, fast and accurate.

Here are some of the key functions and tools used in this chapter.

Gradient mesh
Envelope distortion meshes can also have different gradients applied to them to create realistic gradients.

Photoshop effects filters
Any object can have a Photoshop effect applied to it, and one great advantage of Illustrator is that those effects are non-destructive and can be updated at any time via the Appearance palette.

Blending modes
Blending modes change the way the colours of overlapping objects interact and blend with one another. Here, the fabric texture is blended into the print. Blending modes are found in the Transparency palette.

Mesh warps
Mesh warps enable any pattern tile to be warped to simulate the natural drape of fabric, creases and folds. This function is fully editable and a warped pattern can easily be swapped or updated.

Art, bristle and scatter brushes
These brushes will help to give a more realistic look to a drawing. Art brushes can paint any given shape within a brush-stroke length. Scatter brushes can paint groups of elements over a brush-stroke length. Bristle brushes mimic brushes made of natural materials, enabling mixing and layering.

Effects: Stylize
Illustrator can add stylistic effects to an object. Here a drop shadow effect has been added to the outline shape.

Blending tool
The ribbed hem is created using the blending tool and a clipping mask. This technique allows fine editing and is the most advanced way to create ribbing.

Art brushes

Art brushes stretch a brush design or shape along a given path length. A preset art brush can get you started and usually mimic real media such as charcoal, ink, watercolour, etc. Art brushes can be fully customized and can be created from any vector objects. Let's look at how to work with art brushes.

Note that you can also easily create your own brush by dragging and dropping any object into the Brush palette and selecting Art Brush.

Try as below to use art brushes to simulate creases and whiskers.

1 Go to Menu > Window > Brushes. In the palette go to the pop-up menu and select Open Brush Library. Select Artistic/Artistic Paintbrush.

3 Art brushes are highly customizable. To access the options window, double-click on the brush instance in the Brush palette (not in the Library palette).

The brush instance has a thin width and Flip Along ticked.

2 Select any of the art brushes and with the paintbrush tool, draw on the artboard to experiment with the tool.

The brush has Tint selected as a colourization method. The stroke colour is set to green for the first brush and orange for the second one.

Scatter brushes

Scatter brushes repeat and scatter a brush design over a stroke length. There are plenty of pre-designed scatter brushes available in Illustrator, but as with any other brush type, you can easily create your own scatter brush.

For this tutorial, you are going to create paint splatters on jeans using a vectorized bitmap image as a starting point.

Below: Three identical brush strokes with a random input. To achieve this, click on the brush stroke and the brush instance in the Brush palette: this will randomly apply another scatter parameter.

Note: you can also use a pre-designed ink-splatter scatter brush.

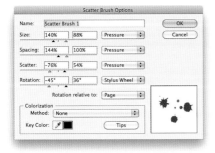

1 Drag and drop the ink spatter into the Brush palette, select Scatter Brush, and set the parameters as above if you have a graphics tablet (if not, try Random for every parameter).

2 Select the brush tool and experiment with the scatter brush created; fine-tune the settings in the brush options if the brush is unwieldy.

3 As with the art brush, apply the Scatter brush on the garment. Do not worry at this stage about overspills: focus on what lies within the outline shape.

4 By selecting Tints (under Colourization in the scatter brush options), you can apply different colours to the same brush instance by selecting different stroke colours in the toolbox.

Blending modes

Blending modes affect the way the colours of overlapping objects interact and blend with one another. The results are very much dependent on which colours are used. We will only showcase the blending modes that are most commonly used in a fashion context.

To better understand blending modes, we will use specific colour terminology:
- Blend colour is the original colour before a blending occurs.
- Base colour is the underlying colour (in this case a blue denim bitmap image).
- Resulting colour is the colour that results from the blend.

The blend colour is blue; opacity is 50%.

The blend colour is yellow; opacity is 50%.

To use blending modes, select the overlapping shape, go to the Transparency palette and select a blending mode.

Blending Mode

Opacity

Screen
Multiplies the inverse of the blend and base colours. The resulting colour is always lighter. Avoid using black or white when using Screen. In the illustration above the blend colour is blue, and the opacity is set to 50% for a subtle effect.

Overlay
Preserves the highlights and shadows of the base colour while mixing in the blend colour to reflect the lightness or darkness of the original colour.

The blend colour is white; opacity is 100%.

The blend colour is white; opacity is 100%.

Opacity
Opacity can be used in conjunction with blending modes or separately. Select an object and then input or use the slider to set an opacity percentage.

Hue
The resulting colour has the luminance and saturation of the base colour and the hue of the blend colour.

Soft light
Darkens or lightens the underlying colour depending on the blend colour.

Feel free to experiment with all the blending modes to find what suits your artwork best.

Expand

All the brushes studied so far are made of a path with a brush appearance applied to it. In this state, a brush's appearance can easily be edited. Yet sometimes a brush needs to be expanded into paths so that it can be edited like any object with anchor points.

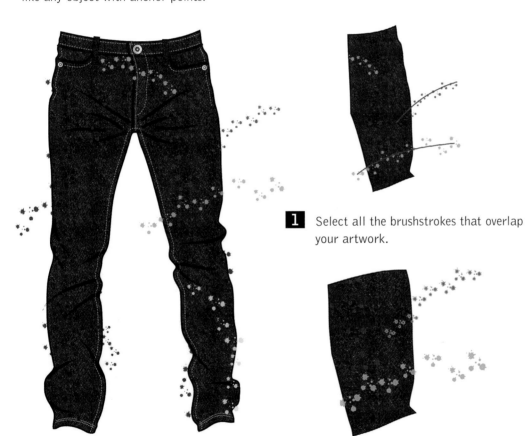

The scatter brush is fully editable but it needs to be expanded to be able to remove the overlaps.

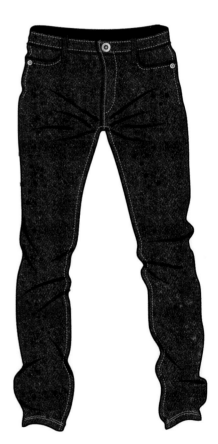

1 Select all the brushstrokes that overlap your artwork.

2 Go to Menu > Object > Expand Appearance. The brushstroke is now a regular object which can be edited further, yet it loses any possibility of having a new appearance applied to it.

3 Finish by erasing the paint splatters lying outside the outline shape by using the eraser tool. Note that when using the eraser tool, blending modes can be compounded and thus lost, so it is safe to ungroup the objects to reinstate the original blending mode.

Bristle brushes

The bristle brush creates the appearance of a natural brush and helps you to paint fluid brushstrokes with bristle details. It can also simulate the effect of various brush media such as watercolour. Bristle brushes allow for plenty of customization of characteristics such as bristle length, paint opacity, etc.

To get the best results out of a bristle brush, you should use a graphics tablet such as the Wacom Intuos 3 or higher with 6D art pen. Illustrator can translate all 6 dimensions of freedom that these tablets provide.

1 In the Brush palette's pop-up menu, select Open Brush Library > Bristle Brush Library. Select a wide brush such as the mop brush.

2 Double-click on the selected bristle brush in the Brushes palette to access the bristle brush's options. There you can adjust the parameters. Try to paint on a bitmap image such as denim fabric; go back to the options to adjust as needed.

Above: The faded effect is obtained with a fan bristle brush, with the parameters set as in step 1 and with an overlay blending mode.

Right: The dyed effect is achieved by using the bristle brush with a black blend colour and a mixture of blending modes such as exclusion, soft light and screen. Note: A clipping mask was created to hide the brush's overspills.

3 Paint as you have with the art and scatter brushes, making sure you add several brushstrokes on top of each other. The bristle brush can be expanded and you can create a new bristle brush (Brush Palette > New Brush Icon > Bristle Brushes > Bristle Brush Options).

Drawing modes

Illustrator has the added facility of allowing you to draw or paint in different modes. This can dramatically cut down the production time when painting complicated surfaces with art, scatter or bristle brushes. The default mode is Draw Normal.

To switch between modes, select the drawing mode in the Tools palette's lower part.

Normal Behind Inside

Draw Behind

Draw Behind mode allows you to either draw behind all objects on a layer (if no object is selected) or to draw behind a selected object.

Draw Inside

This mode allows you to draw inside a selected object. The Draw Inside mode eliminates the need to edit objects that are spilling over or to create clipping masks. The Draw Inside mode only works when a single object is selected.

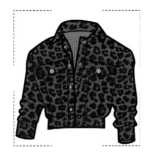

1 Select the outline shape and tick Draw Inside mode in the Tools palette. A dashed frame will appear.

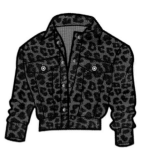

2 With the brush tool and any brush type required, start painting in the shape. Note that you must accomplish this in one go, since as with a clipping mask, once you end the task the drawing mode reverts to normal and all your paint strokes are clipped within the shape.

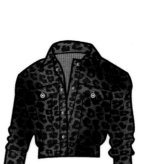

3 To create more painting inside, copy and paste an empty outline shape in front and then tick Draw Inside mode again. (If you do not have an empty outline shape, you can release the clipping mask of the copied outline.)

4 You can edit the paint strokes within a Draw Inside shape by double-clicking on it to enter isolation mode.

Blending tool

The blending tool can be used to great effect for all ribbing designs and also other trimmings. The great strength of the blending tool compared to other techniques for designing ribbings is its flexibility and editability.

Here we want to show the structure of the ribbing, with fold and stretch as it really occurs on a garment collar or hem. So start by selecting a good-quality picture of a polo collar, for example, or any garment that has an interesting ribbing with fold and stretch.

The blending tool (CS5 and CS6 illustrated below) is found in the Tools palette; double-click on the tool to access the options.

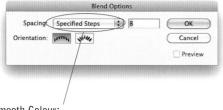

Smooth Colour:

Select to create a colour blend.

Specified Steps:

Controls the input of steps between the start and end of the blend.

Specified Distance:

The distance between steps in a blend measured from edge to edge of the object.

Orientation:

Determines the orientation of blended objects.

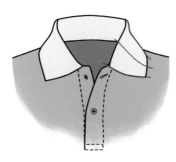

1 Draw three lines, two being the outer edge of the shape that you are adding the ribbing to. Make sure they spill over the edges generously.

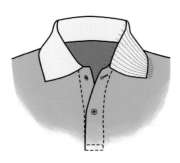

2 Set the blending tool option as follows. Specified Distance: 2mm, Orientation: Align to Path. Select the three lines, then with the blending tool, click on one line at a time, going from side to middle to side.

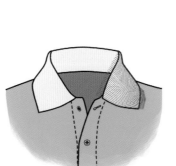

3 Adjust the distance to get the desired spacing between lines of ribbing. The lines can also be adjusted to get an even smoother ribbing. Do this by double-clicking on the lines to enter isolation mode.

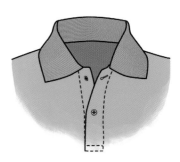

4 Finish by setting the ribbing inside the collar shape using the clipping mask function.

Vector effects

Vector effects reshape objects without permanently changing their structure. Because of this, they greatly enhance design workflow and speed by being fully editable in the Appearance palette.

Use the effects via Menu > Effect > (select a vector effect in the top part of the menu). Then, in the dialogue box, input parameters. An effect applied to an object can be changed, edited or removed at any time via the appearance panel. Effects can be expanded into vector objects.

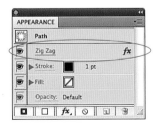

The Appearance palette representing an object with a zigzag effect applied to it.

Distort and transform effects
Within this sub-group, here are a couple of effects that are useful in a fashion context.

Zigzag
Use this to quickly create zigzag stitches; keep the amount on the low side.

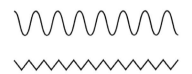

Roughen
This effect can be used for fur collars, to quickly achieve a rough edge.

A simple outline shape is drawn for a furry collar.

Roughen effect. Size: 1.76 mm. Detail: 70 per inch. Absolute and Smooth selected.

The same fur trim with added paint strokes and a gradient fill for a more realistic look.

Stylize effects
Under this sub-group, drop shadow is a quick and useful effect to give any shape added dimension.

The outline shape has a drop shadow effect with a multiply blending mode, 46% opacity, 2.5 X and Y offset.

Round corner
A great effect for quickly adjusting an object's corner edges. Enter a radius value and tick Preview to see the results.

(left) A pocket flap. (right) The same pocket flap with added round corner effect on the outer edge and topstitching with a 2.5 mm radius.

Vector effects: 3-D

These effects allow you to create three-dimensional objects from two-dimensional artwork. The 3-D objects can have lighting, shading and other properties added to them. You can also map images on to the surface of a 3-D object.

3-D objects can be extruded or revolved; they can also be rotated in three dimensions. As with other effects, objects with 3-D effects can be updated via the Appearance palette.

3-D extrusion
A two-dimensional object can be extruded, which means that its depth along the Z-axis can be extended.

Create a 2-D object, and go to Menu > Effect > 3D > Extrude and Bevel. Input as illustrated below to achieve the same result as above.

3-D revolving
The revolving effect sweeps, in a circular motion, a path around the Y-axis to create a 3-D object. Only half the shape of the object needs to be drawn as a front-facing section.

Draw half a rivet. Use Effect > 3D > Revolve, then click on More Options and input as shown below to get the same look and feel.

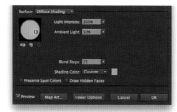

Bevels
Bevels can be added to an extruded object, and can either be extended outwards or inwards, as illustrated above right.

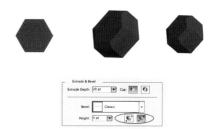

Map art
You can map 2-D artworks on a 3-D object. In the extrude and bevel options window, click on Map Art. Select an image from the Symbol palette and assign it to a surface of the 3-D object.

A bangle created from an ellipse shape with a hollow appearance and a single mapped image on three different surfaces.

Vector effects: warp

Warp effects distort and deform objects, as well as paths, text, meshes, blends and bitmap images. Like other effects, they can dramatically reduce time spent on designing detail variations.

There are plenty of predefined warps to choose from. Most warps have common parameters:
- Bend: The amount of bending (can be both horizontal and vertical).
- Distortion: The amount of horizontal and vertical distortion.

To work with warp effects, select an object and go to Menu > Effect > Warp > (choose one warp effect). In the options window, set the bend amount; optionally, add vertical or horizontal distortion and press Preview.

Warp effects work well when targeted on specific parts of a drawing. Simple geometric shapes and typefaces work well too. The warp function is great for quickly altering the shape of a chest print, pocket detail or trimming. As with all effects, you can also expand warp effects into vectors to retouch parts of the design element more accurately.

Here are a few examples of warp effects used on details and trims.

(Left) Pocket. (Right) Pocket with warp shell lower, and a horizontal distortion of 10%. Note that the button has not been warped to prevent an unrealistic distortion.

Original belt buckle.

The same buckle with a bulge warp and a vertical bend of 33% (effect only applied to the shield part)

Again, the same buckle with a bend of 33% and a vertical distortion of -25%.

It is important to always group elements that will be warped in order to achieve the best possible look and feel.

The bow on the left has not been grouped as a single object. The bow on the right is grouped as a single object with the same warp effect.

Different effects can be applied to different parts of design details to help them fit together realistically.

Left: Collar and bow. Right: The collar has had a warp squeeze effect added, and the bow a warp arch, in order to make them both fit well.

Envelope distortion

Envelope distortion enables the distortion or reshaping of selected objects using various methods, and has the advantage of working on both vector objects and bitmap images.

Envelope distortion with warp effect

To understand the difference between vector warp effects as presented in previous pages and envelope distortion using warp effect, look at the two ties below. Envelope distortion can distort the bitmap's image pattern.

To enable envelope distortion to bend bitmap images, you will need to set up the options. Go to Menu > Object > Envelope Distort > Envelope Options.

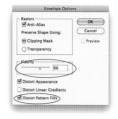

Tick the Distort Pattern Fills button, and increase the fidelity for accurate distortions.

To envelope-distort an object with warp, go to Menu > Object > Envelope Distort > Make with Warp (Command + Alt + Shift + W or Ctrl + Alt + Shift + W for Windows PC). As with vector warp distortion, input the bend amount.

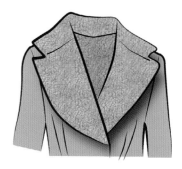

The same drawing with an envelope distortion with warp (wave warp): both the collar detail and the fleece are distorted.

To edit an envelope distortion, select it and use the white arrow to move the mesh anchor points.

The tie on the left uses vector warp effect (flag and wave); the tie on the right uses envelope distortion with warp (same warp effects and same amounts).

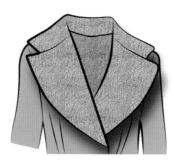

The original drawing (note how the fleece is flat and even).

Envelope distortion with mesh

Meshes allow you to freely distort objects using a grid over an object. Here we will use meshes in two ways, firstly to distort a dress design, and secondly to distort the surface print within the dress shape using a clipping mask.

To use envelope distortion with mesh, select the entire design, go to Menu > Object > Envelope Distort > Make with Mesh (Command + Alt + M or Ctrl + Alt + M for Windows PC). Input a value for the mesh row and columns (keep it on the low side).

A dress design with envelope distortion mesh.

Next, use either the white arrow or the mesh tool to manually distort the mesh.

The mesh tool.

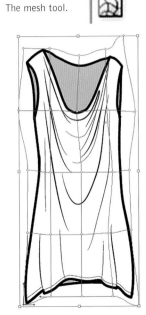

Distorting the mesh can lead to unwanted results, but you can easily revert to the original mesh and start again. Go to Menu > Object > Envelope Distort > Reset with Mesh.

Either maintain the envelope shape or un-tick the box to revert to the original flat mesh.

For mesh distortion on a pattern swatch, copy the outline shape of the dress, draw a box that covers the dress design, and paste the shape in front. Apply an envelope distortion mesh to the box and then distort it.

Create a clipping mask with the outline shape and send it to the back.

Envelope distortion with the warp tool

Using the white arrow to distort envelopes can be time-consuming and bumpy. The warp tool is great for quickly moulding a flat mesh into shape, as showcased here.

The warp tool

1 First, set up the warp tool by double-clicking on it. In the options, set the size and if you have a graphics tablet, tick Use Pressure Pen.

2 Embed a bitmap image of fabric as above. Go to Menu > Object > Envelope Distort > Make with Mesh. Create a mesh with around three rows and columns.

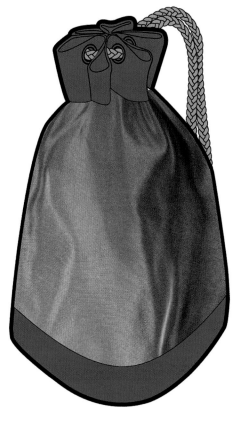

3 Next, select a shape into which you can clip the warped fabric.

4 Using the warp tool, press and drag the fabric to make it fit into the shape.

5 Finish by making a clipping mask using the outline shape and setting it into the chosen design.

Envelope distort with mesh: editing

The content of an envelope and mesh can easily be edited. This is a very useful feature for quickly changing fill patterns or distortion without having to redraw the distortion.

To edit the envelope, select the design and in the control panel, click on Edit Contents (if you have a clipping mask or grouped objects). Follow by clicking on Edit Envelope or Edit Content.

Path. Edit Contents (in clip mask)

Mesh. Edit Envelope Edit Contents

You can also edit the envelope via Menu > Object > Envelope Distort > Edit Contents.

To release the envelope on a given object, go to Menu > Object > Envelope Distort > Release.

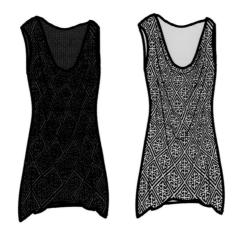

Left: A dress with a fill pattern. Right: The same dress with a different fill pattern, easily changed via the Edit Contents button.

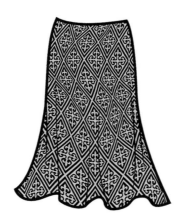

To work fast, you can also recycle an envelope distortion for different designs, thus avoiding the need to create a distortion from scratch.

Envelope distortion with object

Objects can be used as envelopes to shape a distortion. This technique can be useful for a quick distortion on specific shapes.

Select an image or object to distort and an object to use as an envelope.

Select them both and go to Menu > Object > Envelope Distort > Make with Top Object (Command + Alt + C or Ctrl + Alt + C for Windows PC).

Mesh objects

Meshes can also be placed within an object, yet unlike envelope distortion with mesh, a mesh object's outline shape cannot be distorted. Mesh objects are great for creating realistic-looking gradients with the possibility of placing different colours on different grid points. Here we create realistic shading inside the neck opening of a jacket.

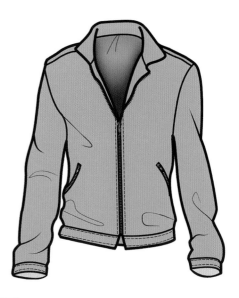

1 Copy and paste the neck opening shape in front (check how to create a separate closed shape in the tutorial on page 83).

2 Select the mesh tool, and with it click on the upper edge of the shape to create vertical mesh lines. Add about four to five evenly spaced lines.

3 Next, add new horizontal mesh lines by clicking on either vertical outer edge. Add more lines where the gradient will be more pronounced.

4 With the lasso tool, select anchor points on which to apply a gradient colour, then select a colour in the Swatches palette to apply. Start with dark colours and work up to lighter colours.

5 Finish by retouching the mesh if needed, by moving or re-colouring individual mesh points to obtain a smoother gradient.

Photoshop effects

Illustrator can use Photoshop effects on both bitmap images and vector objects. Yet, unlike in Photoshop, the effects are non-destructive, which enables quick editing via the Appearance palette. Photoshop effects cannot be applied on linked images, so always ensure that you embed images.

Illustrator is not as fast as Photoshop when rendering effects on bitmap images, so unless you are working on medium-resolution images, consider using Photoshop for more advanced compositions.

To apply effects to bitmaps or vector graphics, select the object and go to Menu > Effects > Effects Gallery (under Photoshop's effects section). In the gallery, select the desired effect in the centre pane.

Effects gallery (Photoshop section).

Multiple Photoshop effects can be applied to an object via the Appearance palette, by selecting a new effect and ticking the Effects icon.

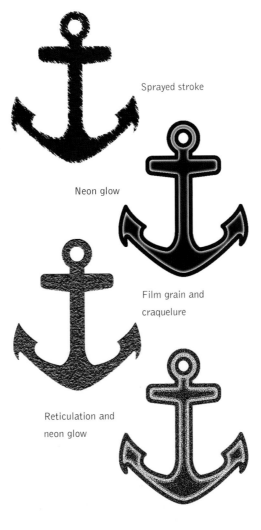

Sprayed stroke

Neon glow

Film grain and craquelure

Reticulation and neon glow

Above: Some of the Photoshop effects available for applying to vector graphics.

Photoshop effects work a treat on bitmap images. Here are a few examples of familiar effects applied to pieces of jewellery.

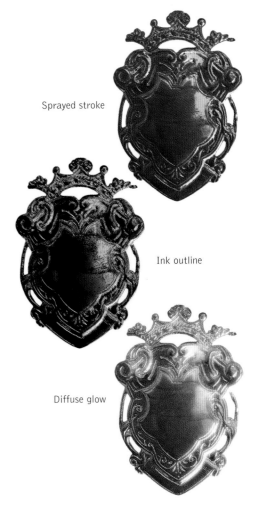

Sprayed stroke

Ink outline

Diffuse glow

Symbols (advanced)

In Chapter 6 we looked at most of the functions related to symbols. Yet more can be done with symbols, and here we focus on how to alter the colour of symbol instances on the artboard. There are three techniques presented here: staining, screening and styling. Each technique will only affect the instances of a symbol and not the symbol itself.

Symbol stainer

The symbol stainer changes a hue towards its tint colour, yet preserves luminosity. This technique will not work on black or white objects.

The stainer tool.

Select the fill colour that you want to use as the colourization colour. Select the symbol stainer tool and drag it over the instances of the symbol that you want to stain. The amount of colourization gradually increases.

When staining, you can also hold the option key or alt key (Windows PC) to decrease the colourization. Hold the shift key to keep the colourization amount constant.

Symbol screener

Transparency can be added to an instance of a symbol. Select the symbol screener tool. Press and drag over the instance of the symbol. Decrease the transparency by holding the option key (alt key for Windows PC).

The symbol screener tool.

Symbol styler

Graphic styles can be applied to an instance of a symbol; the amount and location of styling can be gradually applied.

Select the symbol styler tool. Then select a graphic style (learn more about graphic styles on the following pages). Press and drag to apply.

The symbol styler tool

The original instance of the symbol.

The same instance of the symbol with staining applied to it.

Symbols without transparency.

The same instance of a symbol with symbol screening applied to it.

Before the graphic style is added.

With a graphic style added.

How to work with appearance and graphic styles

Although we have already briefly looked at appearance and graphic styles in previous tutorials, here is a showcase to represent the full extent of the possibilities.

Appearance

Appearance affects the look of an object without altering its underlying structure. Appearance includes fills, strokes, transparency and effects. All appearances are controlled via the Appearance palette.

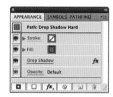

The Appearance palette lists the attributes of an object. Each of these attributes can be directly edited in the palette.

Graphic styles

A graphic style is a set of attributes of appearance, which can quickly alter the look and feel of an object. You can create your own graphic style by using the Appearance palette to provide the building blocks.

The Graphic Styles palette: Illustrator has many pre-designed graphic styles.

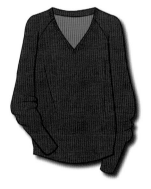

Both graphic styles and appearances should help you to work faster by allowing you to apply pre-designed graphic styles to drawings with one click. This is how to do it.

1 Add all necessary appearances on the outline shape as below (starting from a white fill and a black outline).

First add a bitmap swatch fill appearance, and give it a multiply blending mode.

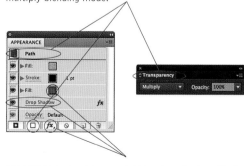

Then fill in a new colour and add a drop shadow effect.

2 Next you need to make the set of appearances into a graphic style by simply dragging and dropping the Path icon into the Graphic Styles palette.

Now that the graphic style is created, it's easy to use for any future design. You can create graphic style libraries (Graphic Style palette > pop-up menu > Save Graphic Style Library), for example a knitted jumper graphic style library.

A quick swap of graphic style gives, in one click, the whole required look and feel.

Bitmap images (advanced)

We have looked at different ways to use bitmaps at a basic level, but now let's look at more advanced techniques. This will require a little bit of assistance from Photoshop.

Advanced clipping

We have shown how to clip a bitmap image in Illustrator, but we can do much more than a simple geometrical shape by doing the clipping in Photoshop first.

1 In Photoshop, open the image and, using the path tool, draw a precise clipping path around the object (see my book *Digital Fashion Print* for how to do this in detail). Save the file in PSD format with a transparent layer. Place it in Illustrator.

Placing dialogue: Unless you need to preserve layers in your image, tick Flatten Layers to a Single Image.

2 The placed and clipped image can now be seamlessly overlaid on a live drawing.

3 Bitmap images can be also clipped inside Illustrator, which can save time rather than doing it in Photoshop. Here we clip away the unwanted elements of a copy of the original image.

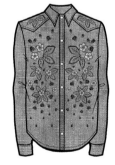

4 Bitmap images can be used as symbols: just drag them into the Symbol palette (all symbol tools and functions are the same as with vector graphics – refer to Chapter 5 for details).

5 Bitmap images can also have Photoshop effects applied to them (a dry brush effect is applied above).

Brushes (advanced)

We looked at brushes earlier, but here are further, more advanced skills.

1 Pattern brush with profile.
Start by drawing a simple pattern brush as below (see Chapter 5 for more details).

Apply the brush on the artboard.

Apply a stroke profile.

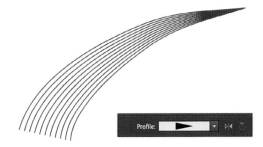

2 Effects can be applied to pattern brushes: first paint a stroke on the artboard, then go to the Photoshop effects gallery.

The original pattern brush.

The same brush with neon glow.

Diffuse glow.

Plaster.

Chrome.

3 A brush cannot be made with bitmap images, yet by using live trace (image trace in CS6), a similar result can be achieved.

The original image.

The image live traced with a six-colour preset.

The resulting pattern brush.

Shape builder tool

When complex shapes need to be drawn, the shape builder tool can help a great deal. This tool works directly on the shape, in a way doing the same thing as some Pathfinder functions such as Unite, but it just feels more natural.

The shape builder tool.

Always decompose an object made up of prime shapes (rectangle, ellipse, etc) where possible and of a drawn path where necessary.

This anchor is made up of three prime shapes and one drawn path.

Note: how the overlapping shapes are flush (use outline mode to help achieve this).

1 Start by drawing the prime shape elements: it's best if you have a reference picture to trace from and here we trace from a clipping from a sportswear bag.

2 Do not worry about rounding corners – just trace everything quite roughly. The most important thing is that shapes should be flush, so that when they are compounded, no uneven surfaces result.

3 Select all the parts you want to merge as a single object, then select the shape builder tool and press and drag across the selected objects to merge them into a single shape.

4 Keep on merging more objects, fine-tuning the shape with the white arrow.

5 Now use the round corner effect to smooth out the hard edges (Menu > Effect > Stylize > Round Corners.)

6 Finish by merging all the bits together and colouring the surface.

Live paint

Live paint is a more intuitive way to colour artwork. The key difference from the regular colouring method is that shapes do not necessarily need to be closed. Live paint can manage gaps by considering them as closed shapes.

The T-shirt on the left is a live paint object – it fills well even with the gap in the neckline; the one on the right is a regular object with a spill-over fill due to the gap.

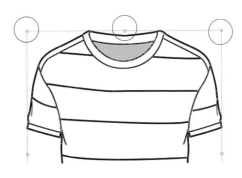

1 Select a drawing without topstitching (to avoid having to fill each stitch gap), then go to Menu > Object > Live Paint > Make (Command + Option + X or Ctrl + Alt + X for Windows PC). Note how the frame symbol changes (circled).

2 Next go to Menu > Object > Live Paint > Gap Options. In the window, set to Small Gaps and tick Preview. While doing this, look at the drawing to ensure that all gaps are detected.

3 Select the live paint bucket tool (embedded with the shape builder tool).

4 Next, create a colour group in the Swatches palette with different fill colours. Select one colour from it: you'll see, next to the paint bucket, the same swatches. The one in the middle is the current one.

5 Start filling in the areas with the desired colours. As you hover above the drawing, a red highlight will indicate the limit of an area to fill.

Note: Live paint objects can be expanded (remain coloured but lose live paint function) or released (go back to a black and white regular object). Both functions are in the live paint menu.

6 Fill in all the colours, and use the arrow key to swiftly change the colour in the bucket.

Chapter 8
Specialist design: footwear, accessories, intimate

This chapter focuses on all the creative issues faced by specialist designers who work in areas such as footwear, bags, jewellery and underwear/intimate apparel. These subjects call for tailored skills, functions and techniques. For example, underwear will have a lot of lace trimmings; bags will need a lot of hardware, trims and straps; footwear will require the visualization of specific parts such as the inner sole and outsole; jewellery will require 3-D effects, metal gradients and pattern brushes, etc. This chapter's content level assumes that most readers will be fluent in Illustrator and have read, understood and practised the content of the previous chapters. This chapter is laid out in sub-groups of specialist areas, so that designers can quickly refer to their particular area. Most pages showcase how a design has been developed, referring to known functions and skills; if any skills are new, they will be explained in detail.

Key skills
- Footwear design.
- Accessories design.
- Underwear/intimate apparel design.
- Jewellery design.

Key Illustrator functions
This chapter uses a mixture of advanced and regular-level functions.

Key learning aims
- To adapt your skills to specialist designs.
- To use Illustrator functions to suit specialist designs.

A freehand flat drawing that includes various skills and functions such as pattern brush and stroke profiles.

Footwear

As with apparel design, the basic foundation for drafting a shoe remains an outline shape and style lines. Most footwear designers will include a side and outsole in their designs; if the shoe has very special features, a top view can be included. Merchandisers like a 3-D view to get a better feel for a design.

Footwear designers can work to a 1:1 scale, since a shoe can fit in an A3 sheet.

Here is a quick development of a sneaker's side view, with skills and techniques specific to footwear design.

1 Start by drawing the silhouetted outline.

2 Draw the key lines that constitute the shoe's different parts and panels.

3 Unless you are using live paint to fill the colours, you will need to splice the different panels to fill different colours. Here we use live paint to work faster.

4 Finish by detailing the topstitching and all other small items that should not be included before the live paint operation (to avoid the endless filling of small areas such as in between topstitches).

5 To add texture, copy the entire live paint object and paste it in front, then expand the copy. Add a texture to each expanded part.

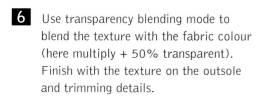

6 Use transparency blending mode to blend the texture with the fabric colour (here multiply + 50% transparent). Finish with the texture on the outsole and trimming details.

Outsole design

As footwear designers know well, outsole design is a very important part of developing a shoe. The outsole mould is also the biggest cost factor, and as such should be carefully designed to avoid wastage. Here is a new technique for quickly developing outsole designs.

1 Draw the outline of the outsole.

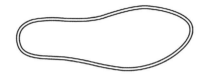

2 Create an offset path using the Offset Path function.

You can also use pattern brushes to create outsoles.

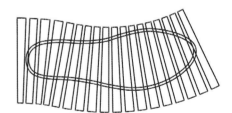

3 Trace the key groove lines, making sure you spill out of the shape.

4 Now make the lines thicker to suit the groove size. Outline-stroke the lines.

1 Create a simple shape and make it into a pattern brush. Give it some spacing and make sure it spills over the edges of the shape.

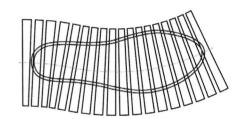

5 Group all the lines as a single object, select the line group and the inner outsole. Use Pathfinder > Divide.

2 Expand the brush.

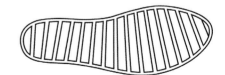

6 Ungroup the object and delete the unwanted bits.

7 Use Effect > Stylize > Round Corners.

3 With Pathfinder > Divide, split overlapping shapes and delete unwanted parts.

Download

Bag design (flat drawing)

When designing bags, one should consider the fact that they contain both soft parts (fabric, straps) and hardware (metal bits, clasp, etc.). It is a good idea to break down these key elements and treat them as separate entities.

To maximize productivity, it is good practice to build a library of bag shapes and straps, which can be quickly added and edited to develop bag variations. As with apparel, bags can be drawn in different styles; here we start with a flat drawing style which can be drawn to scale and used as a pattern to develop samples.

1 Draw the main bag shape using a prime shape. Try to work to scale (e.g. 1:10; 6cm = 60cm). The shape was created with the rounded rectangle tool. Two anchor points were deleted at the top in order to obtain a right angle.

2 Follow with the main elements, designed as standalone parts. The lower reinforcement patches were designed using the pathfinder divide function.

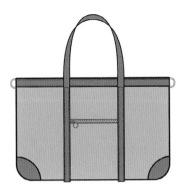

3 Follow with the design of the strap and trimmings. Remember to use libraries so that you can use your trims across different designs.

4 Develop the side view based on the front view. This is important to communicate the way the bag pattern works.

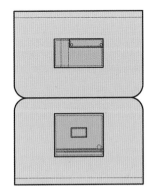

Print out the bag at 1:1 scale. It helps to develop a product which is at the right size before the first prototype is made.

5 Finish with the inside view of the bag to detail the inner pockets. Again, work to scale: it really helps to save costs on sample development.

Bag design (freehand sketch)

As with apparel, bags can be drawn in three different styles. Here we look at a freehand drawing style. The key skill is to draw items in a modular way (each item is drawn as a separate entity).

This tote bag shape was traced from a picture. Style lines were added, and the folds were simplified to give the bag a more streamlined look.

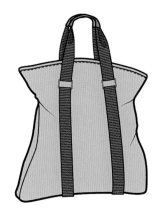

Above: Design of the handle, step by step.

Below: The handles added to the bag (the handles were sent to the back to hide behind the bag at the joining point).

Above: Yet another version rendered quickly using a different strap from a library.

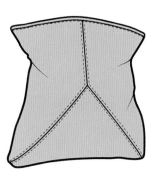

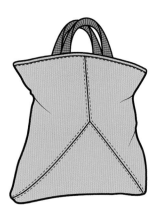

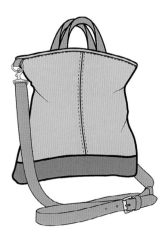

1 Draw the main bag shape using a sketch or an actual picture of a bag.

2 Next, draw the handles. Again this should be done as a consolidated element, which can be reused in other drawings and in a library.

3 This way of working allows for fast updating, taking different straps and trims on and off the bag shape.

Download

Bag design (life drawing)

Bags benefit greatly from a life drawing style, especially since, with this style, a 3-D view can be expressed to help communicate the volume of the bag better. Here we showcase techniques for life-drawn bags.

Right: The drawing of a hand helps with the understanding of proportions. Note how the texture has been rendered using envelope mesh (see Chapter 7 for how to do this).

Below: The main body texture was made using envelope mesh distortion, while the fringes have been moved with the warp tool to create a floating feel. The handle was borrowed from a library and has a freehand drawing style.

Below: This bag uses Effects > Warp (Shell Lower) and bitmap image pattern tiles to give a great realistic drawing style. The overstitching detail was made with a pattern brush.

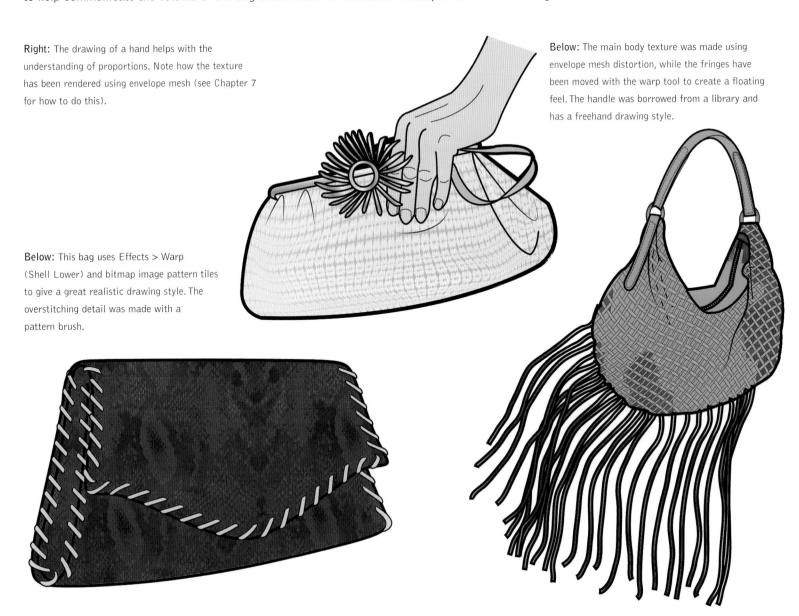

Underwear (flat drawing)

Flat drawings for underwear are important for the development of designs, but are also used quite often on packaging to help consumers understand a product better. When drawing underwear flat drawings, focus on the cut lines and proportions to best represent the product. The use of a dummy really helps here.

1 Draw the outlines first. Toggle the dummy shape on and off to ensure that the design looks good.

2 Draft the back view, still using the dummy shape.

3 Take away the dummy and place the front and back views in the classic layout style.

4 Define the topstitching on the outlines using pattern brushes.

5 Finish with edging, trims design and colouring. Note how the shading can help with defining the flat shapes.

Underwear (lace design)

An important part of lingerie is lace which, due to its complicated design, can be difficult to handle on flat drawings. Here we transform a lace trim into an Illustrator pattern brush.

1 The first step is to find a good image of lace. Either take a picture of some lace, source it from the Internet or even better, scan a sample of lace.

2 Quite often, lace can be skewed, have defects or be uneven, so it is essential to retouch the image. The first step is to adjust the levels in Photoshop to make the lace pure black and white.

3 Still in Photoshop, you must now create the repeat pattern so that the lace sequence will be a seamless pattern brush.

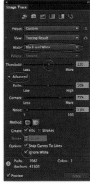

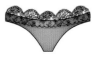

4 Open the retouched lace image in Illustrator, select it and go into the image trace panel (Menu > Window > Image Trace). Set the parameters as above.

5 Expand the trace into vectors (in the control panel).

6 Drag and drop the trace into the Brush palette, create a pattern brush and apply it to the lingerie flat drawing.

Underwear/intimate apparel (life drawing)

With underwear, the accurate rendering of surfaces such as satin is often required. Here various techniques are used to design a silk camisole with a lace trimming.

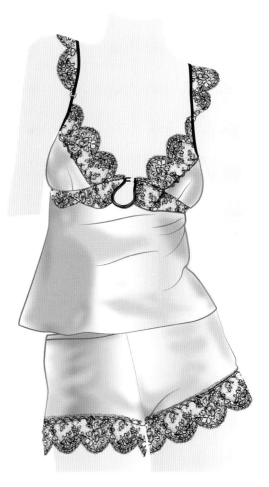

1 Find a source image from which you can trace the camisole's outline. Adapt the design to your own creation, but retain the way the fabric flows and creases.

Above: The foundation of the satin effect fill was created using a neutrals gradient swatch from the gradient swatch library. Note how on the breast cup, the gradient has been rotated to follow the fabric grain.

2 Hide the traced outline temporarily and using the template image, draw the fabric's shading and creases with the pencil tool. Fill them with slightly darker or lighter colours and give them a Gaussian blur effect.

Left: Three pattern brushstrokes with clipping paths.

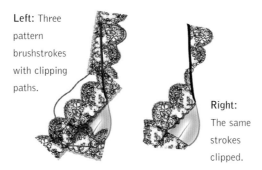

Right: The same strokes clipped.

3 With a lace pattern brush, build the lace trimmings. Use a clipping path to hide unwanted areas.

4 Finish by drawing the body shape to give a better sense of proportion. Make the body fill colour faint in order to keep the focus on the camisole.

Jewellery (flat drawing)

For jewellery design, functions such as pattern brushes to make chain links and live paint for quickly filling
in multi-faceted stones can save time. Here we create a simple necklace made out of beads.

1 Start by designing the bead's shape
using prime shapes.

2 Scale and duplicate the original bead
into several sizes; make sure you un-
tick Scale Stroke and Effects in the
preferences panel so that the stroke
size is always the same.

3 Make the beads live paint objects and
quickly fill them in using a swatch
library (here foliage colour harmony).

4 Draw a simple path to outline the
necklace's shape.

5 Create a pattern brush for the
necklace's top part as above, using the
same beads. The pink frame represents
the repeat tile, which should be sent to
the back as a no-fill, no-stroke box.

6 At this stage, you can either make the
beads into symbols or manually set the
beads into the necklace shape: it
depends on how you prefer to work.

The finished necklace. The beads were set manually as
there were not so many and it was faster than using the
symbol sprayer.

Jewellery (flat drawing)

As with bags, jewellery can be drawn to scale. Flat drawings in jewellery are closely related to technical pack development; here we design a bracelet to scale and ready to be placed in a technical pack file. Use a template to ensure that the proportions are correct.

The chain link design and the resulting pattern brush.

2 Draw the side view of the chain link using the pattern brush as a template.

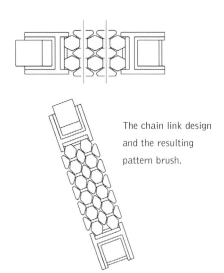

1 Design the pattern brush for the chain link, including the clasp ends.

3 Draft the stones using prime shapes.

4 Fill in the stones with a single colour. Draw random shapes and fill them with slightly different hues. Apply transparency to create a fast, realistic gem effect.

5 Finish by setting the gems on to the bracelet. Print out the design at 1:1 scale to get a feel for its real size.

Jewellery (life drawing)

The creation of fashion jewellery is often about composing designs from individual elements bought from suppliers.
In the context of life drawing, we look at how to make this design process fully digital.

1 Source, online or otherwise, the various components needed to assemble the jewellery design.

2 In Photoshop, knock out the background. Each element should be on a different layer (see my book *Digital Fashion Print* for how to do this). Save in PSD format.

3 Open the file in Illustrator, selecting options as above in Photoshop's import options.

4 Drag and drop each element into the Symbol palette.

5 Design using the selection tool and rapid duplication to spawn the original elements, or by using the symbol sprayer tool.

6 Use the pattern brush to create the chain links.

7 Add some effects to the chain links so that it feels more like a life drawing. Here we used Effect > Artistic > Neon Glow.

8 Finish by setting the necklace chain and clasp. Note: This design could also be developed entirely in Photoshop, yet the flexibility and editability of Illustrator gives it an edge.

Chapter 9
Design communication: presenting and sharing

We live in the age of instant communication, in which the Internet and the digital revolution have brought us multi-channel and multi-device communications, but along with the opportunities come pitfalls. As such, it is crucial to know how to share files across platforms and devices, in order to deliver work swiftly and to present designs in the right format. This chapter looks at different communications formats and discusses how to prepare files to share them between different applications and operating systems. Too often,

young designers halve their job opportunities by emailing impossibly large portfolios that will clog the recipient's inbox, or seasoned designers fail in their handovers because the format is unreadable across platforms. We will also look at Adobe Acrobat Pro and its advanced features for producing and managing PDF files. It is important to communicate and transfer your designs out of Illustrator's environment properly, and this chapter will help you to do it in the best possible way.

Key skills
- Make a mood board.
- Produce a design sheet.
- Make SKU sheets.
- Put together a technical pack.
- Produce a line book.
- Create a portfolio.

Key Illustrator and Acrobat Pro functions
- Paste Remembers Layers
- Paste On All Artboards
- Exporting PDF
- Optimizing PDF
- Acrobat Portfolio
- Acrobat Pro's comments tool
- Exporting JPEGs

Learning aims
- To understand that good communication always results in better product development.
- To prepare and save files that are solid, 'light' (lean files are best) and cross-platform-friendly.
- To know how to prepare PDF portfolios and PowerPoint files from AI files.

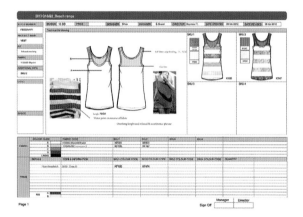

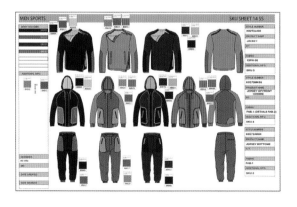

Examples of pages from technical packs.

Mood board

A season always kicks off with a theme, inspirations and a mood board. This allows the creative team to express their vision a year ahead of time for regular fashion cycles, or a couple of months ahead for fast fashion. The mood board contains inspirational images, a description of the theme, looks, graphics, textures and colours. The key skills needed to create a mood board are layout and image editing. For key looks, the image quite often has to be clipped using the pen tool and a clipping path. It is better to place images without embedding them, so that the file does not become too 'heavy'. Most of the Illustrator functions used on a mood board have been showcased in earlier chapters.

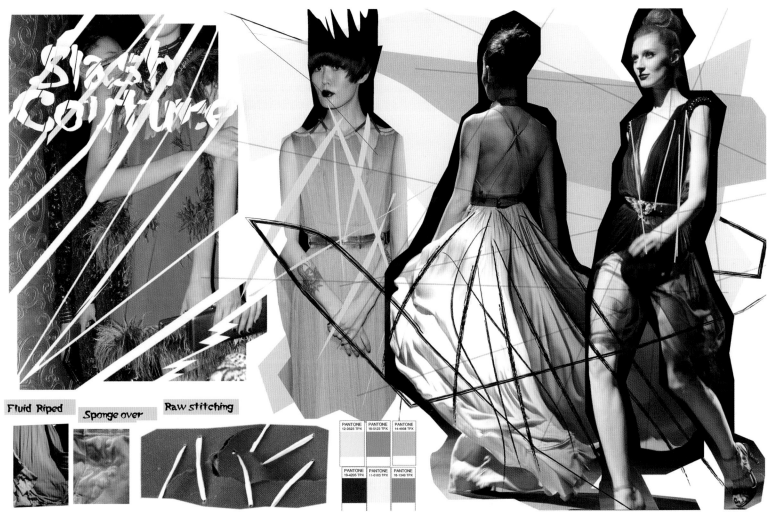

A mood board containing all the key elements (Charles Bédué).

Design sheet

The first stage of design development comprises the use of a design sheet for each design. For some companies, the design sheet is a first step; for others (particularly in fast fashion), the design sheet is the most important part as it usually goes directly to the factory. A design sheet will include the front and back view of a garment, fabric sample, trims and any key details or construction required. Freehand drawings (hand-drawn or Illustrator-drawn) are well suited to a design sheet, especially if no technical pack is developed: they convey better the look and feel of a design.

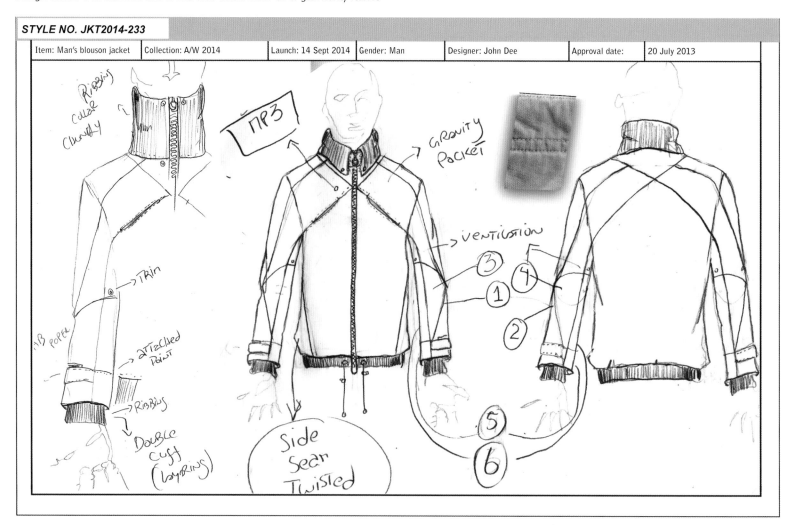

STYLE NO. JKT2014-233

| Item: Man's blouson jacket | Collection: A/W 2014 | Launch: 14 Sept 2014 | Gender: Man | Designer: John Dee | Approval date: | 20 July 2013 |

A design sheet with all key elements: front and back drawing of the garment, fabric swatch, close-up details and basic information.

SKU sheets

After design sheets, SKU sheets come next in the workflow. These represent each finished design in all available colours. Usually, designs are either signed off or rejected at this stage, so good communication is essential. You can fit about three designs into a landscape A4 SKU sheet. Some designers like to keep all their SKU sheets in one document for ease of overview, but this can dramatically reduce the performance of a regular computer.

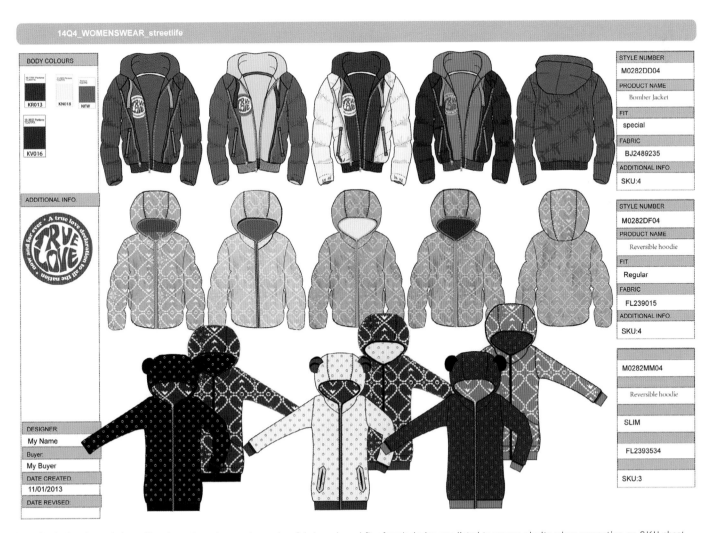

An SKU sheet displaying three designs. Key elements such as code number, fabric code and fit of each design are listed to ensure clarity when presenting an SKU sheet.

Technical pack

The last stage before handing a design over to a developer is the production of a technical pack. Here we give an overview of the format used, and the key parts that a technical pack must have in order to ensure a good handover. The first page includes a back and a front view as well as all the SKUs. Fabric and graphics are listed too.

The second page has a detailed black-and-white drawing with an indication of the fabrication to help the developer. The third page shows trim development: some companies have separate files for this. Finally, the last page has an itemised list of components, which indicates the components under each SKU.

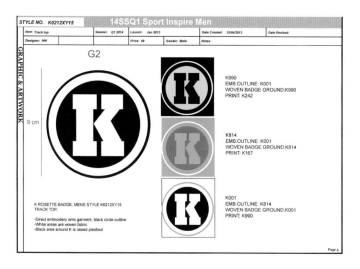

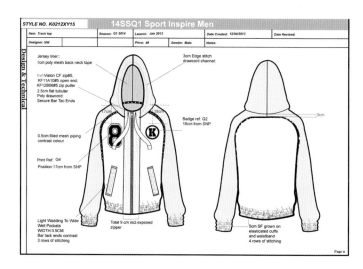

Layout templates

The preparation of a layout template is useful, since it can be reused every season. Here we showcase a line book. However, the skills involved are relevant to any of the layout formats showcased previously in this book.

1. Start by opening a new document. Choose the right format (in this case A5 landscape). Name the first layer grid, and draw the elements of the layout grid. Lock the layer.

2. In a new layer called 'Copy', type in the seasonal copy (article, season, code number and product information).

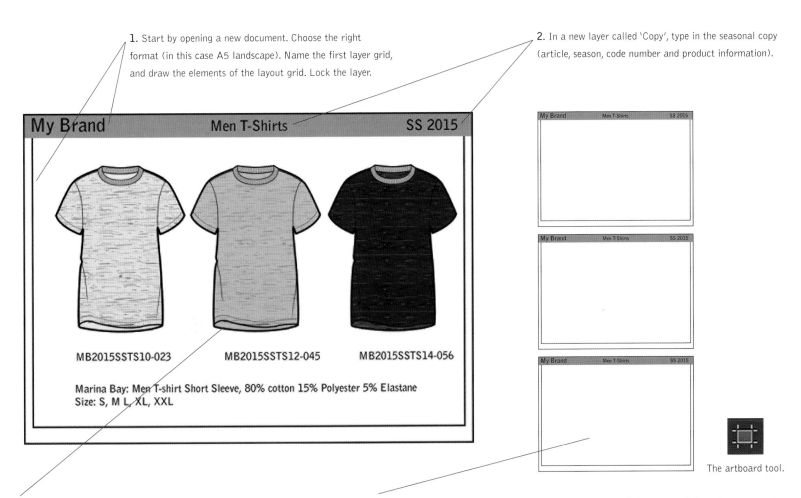

The artboard tool.

4. You will need to bring in designs from other documents, so ensure that Paste Remembers Layers is ticked so that your drawing pastes in the same layers as the document it came from.

3. Create new pages in the document, then copy all the grid elements and the written copy onto all the pages using the artboard tool's Paste On All Artboards function (Menu > Edit > Paste On All Artboards, or Command + Alt + Shift + V (Ctrl + Alt + Shift + V for Windows PC).

Exporting a PDF file

Developers and factory agents might not have Adobe Illustrator, so designers should know how to export a 'light', secure and well-packaged PDF. We also look at how you can password-secure a file so that only your chosen recipient can open and print it.

Highlighted are the unused swatches, brushes and symbols of the document before being discarded.

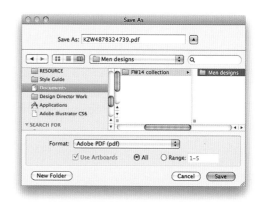

2 Next, get rid of unused swatches, brushes and symbols by clicking on the respective palette's pop-up menu and choosing Select All Unused, then clicking on the Trash icon.

3 Next, do a Save As of the file and under Format, select Adobe PDF. Select a range, or all artboards to be exported.

1 Once a file is ready to send, do a pre-flight check on the typefaces by going to Menu > Type > Find Fonts. In the window, replace all the fonts in the document with a ubiquitous font such as Arial or Helvetica: this will ensure that the recipient can view the font (and so there is no need to embed too many fonts). Note: If you have any special graphics using fonts, ensure that they are outlined before you replace any fonts.

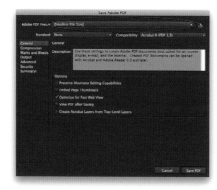

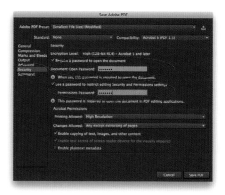

4 Select Smallest as the file size in PDF Preset.

5 Under Security, set to Only Open File with Password, and allow printing. Finish by pressing Save PDF.

Optimizing a PDF file

Even with broadband technology, knowing how to optimize a PDF is a must. Frequently, the deadline is tight and the recipient cannot access a dropbox folder, which usually results in the sending of a last-minute e-mail with a PDF. To do this, the PDF file needs to be optimized (note that you will need Acrobat Pro to optimize a PDF).

1 Open the PDF file in Acrobat Pro and go to Menu > Advanced > PDF Optimizer.

2 Click on Audit Space Usage in the top right-hand corner. Look for the percentage that is the highest (it is most likely to be Images). Press OK.

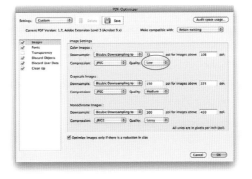

3 Change the image quality to Low and Downsample to 72 ppi. Press OK.

Size	Kind
8.4 MB	Adobe PDF document
3.6 MB	Adobe PDF document

The low-resolution version of the file comes in at less than half the size in megabytes.

4 Right after this you will be prompted to do a Save As on the document: use the same file name and LR (for low resolution). Press Save.

Make a 'light' PDF from multiple files

With Acrobat Pro, it is easy to make a single low-resolution PDF from multiple AI files. This is useful when you need to quickly make a 'light' PDF document to be e-mailed, from different files made at different times.

1 To make a single PDF, in Acrobat Pro go to Menu > File > Combine > Merge Files. Click on Add Files, locate the files you want to add, and then select the small File Size icon and press Combine Files.

2 Next, you will be prompted to save the file.

3 Check and optimize the file size, as shown previously, if necessary; try to meet a target of below 5MB. Note: Multi-page AI files will have all pages included in the PDF. You can also merge AI files with JPEG and even PDF files.

PDF Portfolio

A fast and efficient way to send several multiple-page PDF documents in a single portfolio is to use Acrobat Pro's Portfolio feature. Here is how to prepare a well-packaged and 'light' portfolio that can be easily sent by e-mail without clogging anyone's inbox. The key to a 'light', good-looking Portfolio file is the source PDF files – ensure that you compress the images well and get rid of any unwanted clogging data (see previous pages for how to do this). PDF Portfolio is simply a container of multiple PDF files that makes viewing a PDF a trouble-free experience for the end user, which is especially crucial if you are seeking work!

To get started, in Acrobat Pro, go to Menu > File > Create PDF Portfolio. See the key features below for how to create the Portfolio file.

The Home button
Brings you back to what the portfolio will look like for the end user.

Choose a Layout
This selects the layout type that an end user will see.

Add Files
Click on Add Files (if the required files are not in the same location), or on Add Existing Folder (if they are). Make sure the file names are easy to understand for an end user, as this is what he or she will see on the portfolio.

Add Welcome and Header
Use this to create a title page for the portfolio and a header.

Publish
By pressing this button, your portfolio will be ready to be sent.

Acrobat Pro comments tool

In order to ensure good products, smooth communication between factories and designers during the development phase is critical. Acrobat Pro's comments tool can help facilitate communication. With a multiple-page PDF, Acrobat Pro is much faster than Illustrator for the reviewing of designs, prints or samples. Note: If some changes require more detailed drawing (such as the ribbed cuff below), simply open the PDF in Illustrator, draw the

details and save the file. You can easily open it in Acrobat Pro later for further comments.

Reveal the comment toolbar by going to Menu > Tools > Comments and Markup > Show Comment and Markup Toolbar

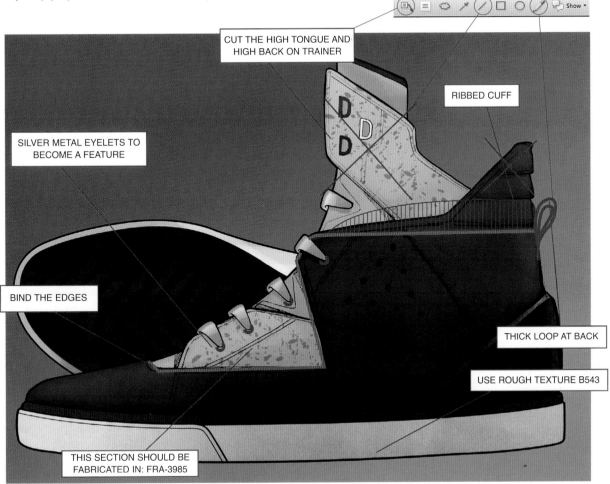

A shoe design with comments made in Acrobat Pro using various comments tools.

Exporting JPEGs for PowerPoint documents

So far we have not saved files in any format other than AI or PDF, yet Illustrator can export files in many useful formats. Let's look at one option: Microsoft PowerPoint (PPT). This is a popular format, which can be requested by some companies or by merchandizers not used to working on creative applications.

Here we create a new document suited to the PPT format for screen projection.

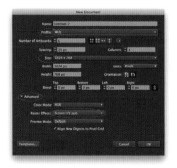

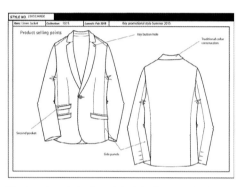

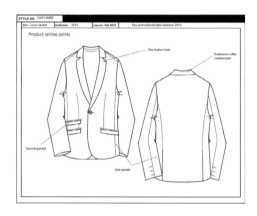

The top sheet is in the original A4 format; the sheet right has had its frame extended to fit the screen size of a PPT document.

1 Create a new Illustrator document. Under Profile, select Web; select a size of 1024 x 768. Tick the Advanced Tilt button and choose Raster Effect: 72 ppi; press OK. If you know how many pages your presentation will consist of, input it under Number of Artboards.

2 Either create content from scratch or, as shown previously, copy and paste content from other documents. If you use an A4 or A3 format, you will need to adjust the layout to fit the screen format.

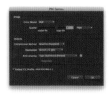

3 Go to Menu > File > Export. Select JPEG in the pop-up menu at the bottom and tick Use Artboard: All (if you have more than one page). Then, in the Options, input as above. Press OK.

4 Go to PowerPoint and create a new document. Then, in the menu, click on the Picture icon and select Picture from File.

5 The picture will fit perfectly on the PowerPoint artboard.

Chapter 10
Troubleshooting and trade secrets

The use of Illustrator in a fashion context is relatively recent and generally speaking, fashion designers are consequently less computer-literate than, say, graphic designers. Fashion designers tend to find their own way to draw a fashion flat drawing, and this would be fine if every designer always worked alone. But of course this is not the case, and in a company set-up, a designer might be called upon to update another designer's drawing. This chapter will help you deal with the drawing from hell that is hard to update or redesign. We will also look at other issues that commonly cause problems in Illustrator and how best to troubleshoot them quickly. Finally, we will look at some 'trade secrets' from experienced senior designers. These advanced techniques will help you work fast, cope with the pressure of deadlines, and deliver designs on time.

Troubleshooting key Illustrator functions and skills
- Ribbings
- Pattern brushes
- Stray points
- Envelope distortion on bitmap images
- Fragmented outlines
- File compatibility

Trade secrets key Illustrator functions and skills
- Fast merchandizing boards
- Modular updating
- Fast updates for life drawings
- Fast updates of an SKU sheet
- Fast life drawing updates using the pencil and eraser tools
- Fast symbol updating

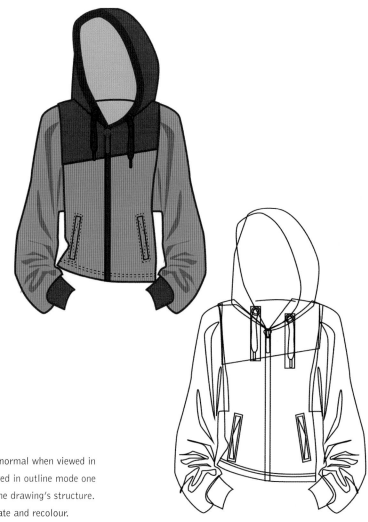

Although the drawing appears normal when viewed in preview mode (left), when viewed in outline mode one can clearly see the issue with the drawing's structure. This will be a challenge to update and recolour.

Troubleshooting ribbings

In several chapters on detailing, we have looked at how to draw ribbing using different techniques and by working with brushes. Let's now look at some of the problems associated with each technique and how to fix them.

Ribbing using stroke in a clipping mask

This technique (see Chapter 5, page 78) can pose problems when curves are used in a path line.

The ribbing is skewed because the Bézier curve handle has been badly positioned.

To resolve this, go into isolation mode to reposition the handle bar.

Ribbing using the blending tool

When using the blending tool (see Chapter 7, page 116), a classic error is to click on different areas of each building line as the blend is created.

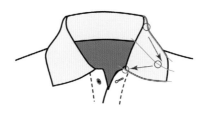

Above: The three building lines (in blue) are used to make the blend. (below) When it was created, the user clicked from top left to bottom right and back again, which resulted in a warped blend.

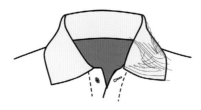

Always ensure that you stay in the same position on each building line when clicking on it.

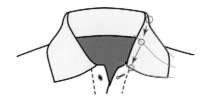

Troubleshooting the pattern brush

Although very adaptable, a pattern brush can encounter problems when the path it is drawn on tightly curves. In this situation, the brush can 'collapse' on itself. Here is how to resolve the issue.

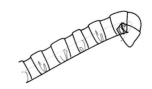

The path's curve is very tight, resulting in a collapsed pattern brush.

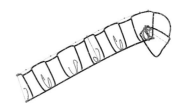

First, expand the pattern brush.

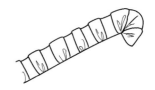

Next, edit or remove the problematic paths.

Troubleshooting stray points and envelope distortion

We now move on to more subtle issues that can arise when working in Illustrator. They are more subtle because they might not always be an issue, depending on where they are located (in the case of stray points) or how much distortion is applied (in the case of bitmap images).

Stray points

Too often, the development of artwork generates stray points (anchor points without segments), which can become a nuisance when joining paths together.

If a joining operation (see page 39) throws up this message, it is often caused by stray points.

To avoid this, always do a stray point clean-up. Go to Menu > Select > Object > Stray Points. Then press Delete.

Stray points are not visible in preview mode (top), whereas in outline viewing mode, the stray points are revealed as little 'X' marks.

Troubleshooting envelope distortion on bitmap images

When using pattern swatch bitmap images on envelope distortions, it can often result in gaps between the tiles of the swatch.

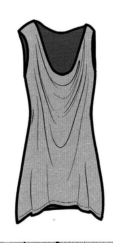

This dress, with an envelope distortion bitmap image, has noticeable gaps.

To resolve the problem, go into isolation mode to extract the envelope distortion (see

Chapter 7, page 121, for how to do this). Copy the envelope and paste it into Photoshop.

In Photoshop, use the clone tool to get rid of unsightly lines. Open the cleaned-up image in Illustrator and set it in the outline shape as a clipped image. The envelope distortion cannot be distorted any more.

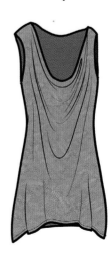

Troubleshooting fragmented outlines

If you inherit another designer's drawing and need to colour it, only to discover that the outline is badly fragmented and it would probably be faster to redraw it from scratch, don't panic. This is what to do.

Rebuilding fragmented outlines

This drawing looks innocuous enough – until you start colouring it (bottom).

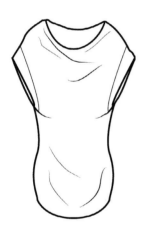

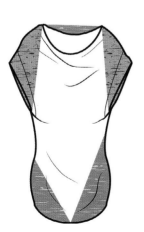

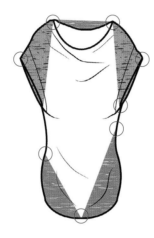

Start by spotting the places where the outline segments start and stop. Then, with the white arrow, select two end anchor points and join them (make sure there are no stray points and more than two anchor points).

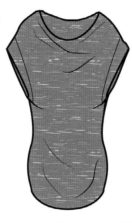

As you join the fragments, the drawing will fill up properly again.

Using live paint on a fragmented outline

If, as in this case, the drawing does not contain topstitching, you can also swiftly resolve a fragmented outline using live paint.

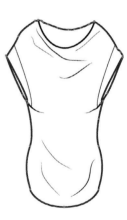

First, select every fragment (above), then create a live paint object (below).

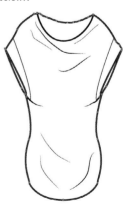

Troubleshooting file compatibility issues

When files that need to be viewed by various people are saved in the right format, with the correct parameters, it makes all the difference. Unfortunately, more often than not you will receive files that have lost their editability or which have key elements outlined, making them much harder to edit.

This happens when a file has originated from an older or a more recent version of Illustrator than yours, or when a PDF file has been saved without ticking Preserve Editing Capabilities. Let's look at how best to solve these issues.

Non-editable PDF

Quite often, a designer will save PDF files with a small file size setting, to make them 'light' and e-mailable.

When you need to edit such a file back in Illustrator, you will need to 'decompose' it, as Illustrator will have randomly compounded various unrelated objects depending on how the file was saved.

In this PDF file, three SKUs out of four have been compounded, and some crease details have been omitted (left).

To resolve this, use the white arrow. First, look at the document in outline mode to see what lies behind the preview. Select drawings one by one and cut them into a new document in order to have the space to update the design.

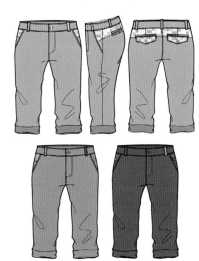

The design is extracted from the PDF using the white arrow (above) and updated to a new version, even if the file has been saved as a low-resolution PDF (below).

Legacy format issues

Swapping files between different versions of Illustrator can cause anything from minor issues to not being able to open a file. For example, a pattern brush can be lost when a document saved in a legacy format is opened in a newer version of Illustrator. So if you receive a drawing saved in CS4 and you work in CS6, the brush will certainly be expanded.

Left: A brush created and saved in CS4 (still fully editable). Right: The same brush, opened in CS6, has lost its editability, and is now a normal vector object.

To avoid this situation, request that files are saved as an EPS or PDF with Preserve Editing Capabilities ticked. Ideally, request several versions, so you can test out which one works across versions and platforms.

Trade secrets

When a deadline is fast approaching and the pressure is on, it helps to have a few tricks up your sleeve; these can make all the difference between delivering on time or a failure to do so. The following four pages focus on 'trade secrets' that will allow you to transform existing drawings into new ones when there is no time to work from scratch.

Fast merchandizing boards
You might be asked to compose merchandizing ('merch') boards or looks from a collection of flat drawings, to support the visual merchandizing team. The Clipping Mask function is a lifesaver for this task, when used properly.

The back view has come to the front due to the clipping mask.

1 Start by bringing all the drawings needed to compose a look into a new document. Ensure that each flat drawing is grouped.

2 Compose the look by moving the drawings into a single block. Next, ascertain which parts are not supposed to be visible (in this case the back view of the jacket's left sleeve). Draw a quick shape for the clipping mask using the pencil tool.

3 Follow by making the clipping mask. Often, the object will come to the front of the stacking order: send it to the back. You can also quickly adjust the mask's path if needed, as the pencil tool can be unwieldy.

4 Finish by clipping the front view if needed (here the back hem has been clipped away).

Modular updating

Be smart: when time is plentiful, make flat drawings that have variations built into them, so that when time is tight, you can use these variations in an instant.

Here we take a simple T-shirt. In less than one minute, you can update it into three different versions.

To transform the T-shirt's set-in sleeves into raglan sleeves, the sleeves are brought forward, then the 'collar' and topstitching, to adjust the stacking order.

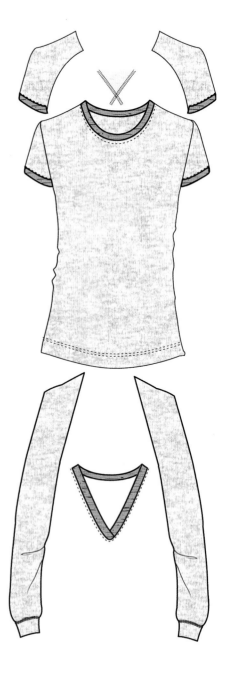

A T-shirt with a regular sleeve and modular construction. Outline mode allows it to be changed swiftly into a raglan-sleeved version.

Pushing this concept further, it is helpful, when designing blocks, to use a matrix approach in which each variation of a garment type is designed at the same scale and thus made to fit. This takes time, but the results are invaluable. Simply build 'body parts' of all the possibilities and variations found in a garment type as you go. When an update is requested, you can call on those parts to provide a super-swift update to a design.

Fast updates for life drawings

To update life drawings quickly, you need different tools. The pencil and eraser tools can work wonders when used properly, allowing you to alter a design in much the same way as you would with a real pencil and eraser.

We looked briefly at the technique in Chapter 1 (page 41). Now let's show how powerful, fast and intuitive this technique can be.

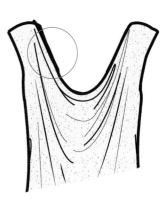

A life drawing of a draped T-shirt dress that needs an update. The only fast way to do so is by using the pencil and eraser tools.

1 Make sure the drawing is grouped. With the eraser tool, rub away the sleeves (time: 15 seconds).

2 Take out the knotted back, again using the eraser. If you get an unsightly line on the collar edge due to fast erasure, use the white arrow to fine-tune it (time: 1 minute).

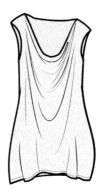

3 Draw the back panel with the pencil tool, and send it to the back (time: 30 seconds, if that!).

4 Finish with a warp effect to quickly change the overall shape. Here, we've used Warp > Shell Lower and Warp > Squeeze.

Download

Fast update of an SKU sheet

Many designers find the updating of SKU sheets to be the bane of their lives, whether this consists of small details on one drawing, or all SKU sheets or, even worse, entire ranges.

For example, let's assume that the main brand label, placed on most designs, has been updated dramatically and the designer must update the SKU sheets as fast as possible. Fortunately, he or she has used the symbol panel to make the label.

1 The brief comes in: here is the new label design, and you must update all the affected SKUs.

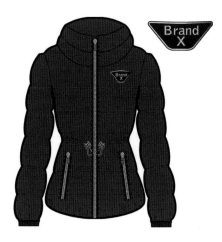

2 Open the affected SKU sheet, and copy and paste the new logo into the document (anywhere is fine).

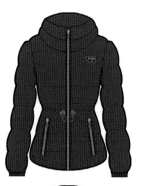

3 In the Symbol palette, locate the old logo. Double-click on the old logo symbol in the palette to enter isolation mode.

Note that it is very important, when updating the symbol, to respect the size and centre point to prevent changes in position and scale on the SKU. (In blue: the outline of the old symbol and the centred position.)

4 In isolation mode, paste the new logo and delete the old one.

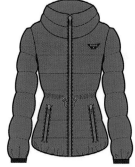

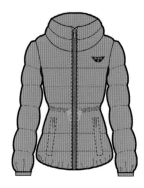

All SKUs are updated automatically.

Chapter 11
Libraries

This appendix contains elements that are commonly used when designing fashion in Illustrator, grouped by genre. The main focus is on Pattern Brush for various stitching techniques, but there are also key details used often on most garments (such as pockets, collars, cuffs etc.), and trims such as zip pullers, buttons and metal bits.

All the artworks presented here are downloadable, via the publisher's website, as EPS files. This format is the most flexible for any version of Illustrator. So go ahead: download, use, modify and create!

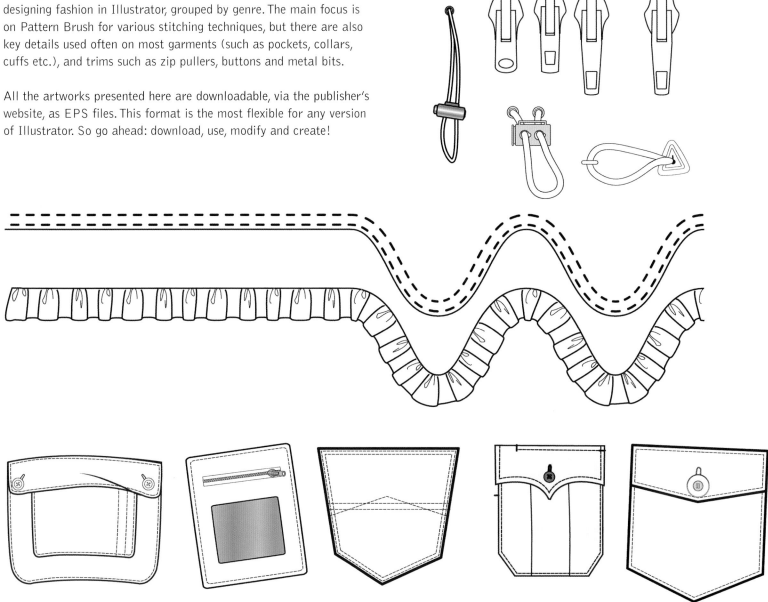

Some of the key items in the library.

Classic topstitching

A stitch pattern brush mostly using single elements. The spacing value in the brush options window will control the gaps between the stitches.

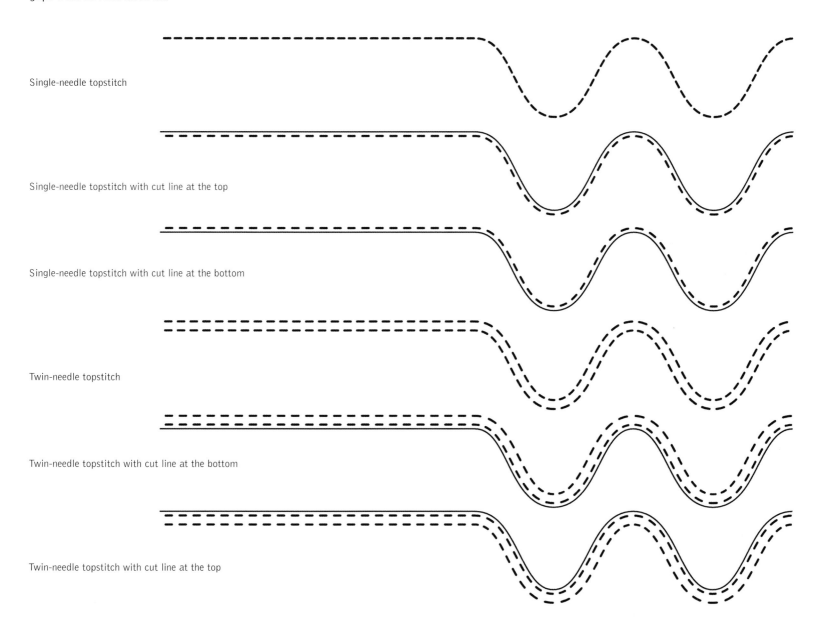

Single-needle topstitch

Single-needle topstitch with cut line at the top

Single-needle topstitch with cut line at the bottom

Twin-needle topstitch

Twin-needle topstitch with cut line at the bottom

Twin-needle topstitch with cut line at the top

Classic overlocking and zigzag

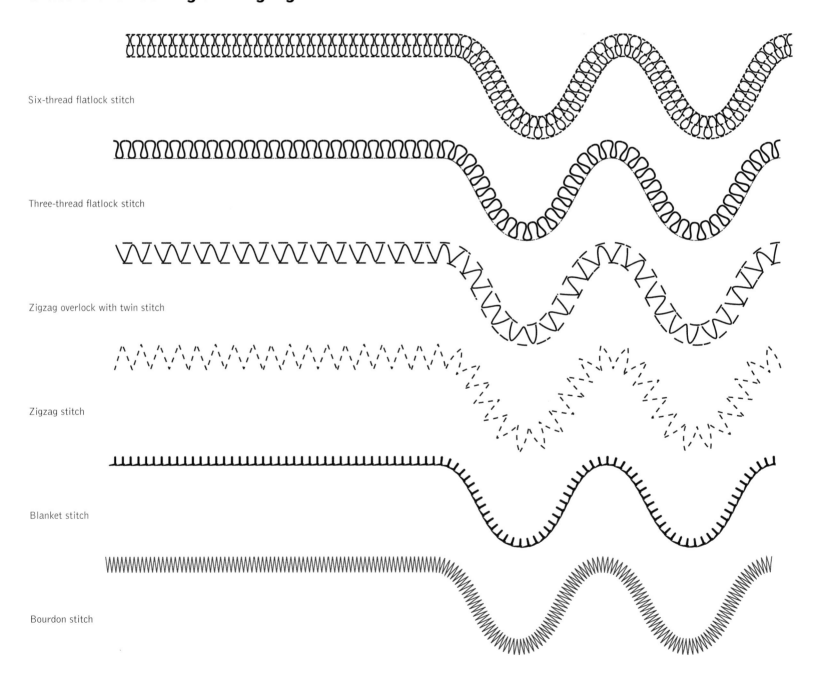

Six-thread flatlock stitch

Three-thread flatlock stitch

Zigzag overlock with twin stitch

Zigzag stitch

Blanket stitch

Bourdon stitch

Chain links

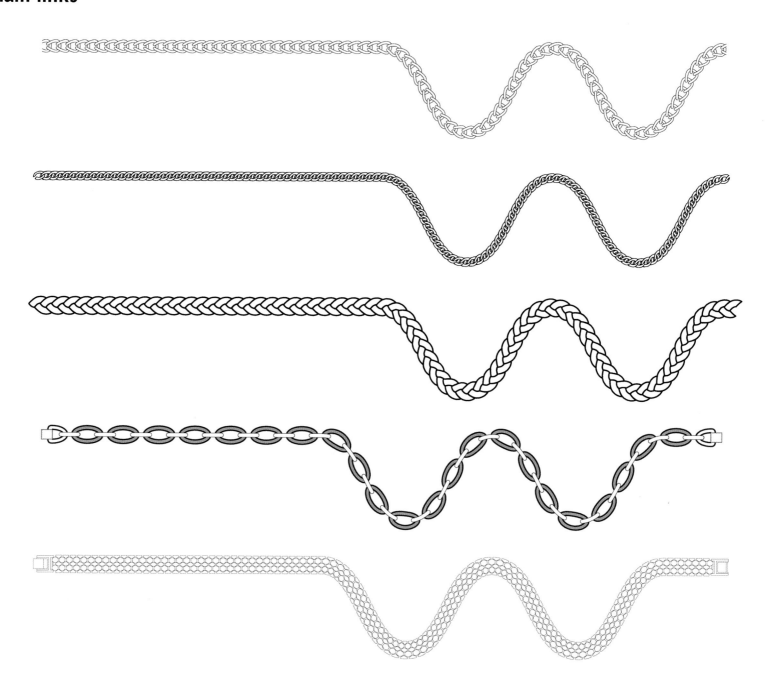

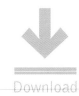

Classic zipper tapes

Metal teeth, tape closed

Metal teeth, tape open

Coil zip tape

Coil zip tape, open

Vislon tape

Elasticated tapes and ruching

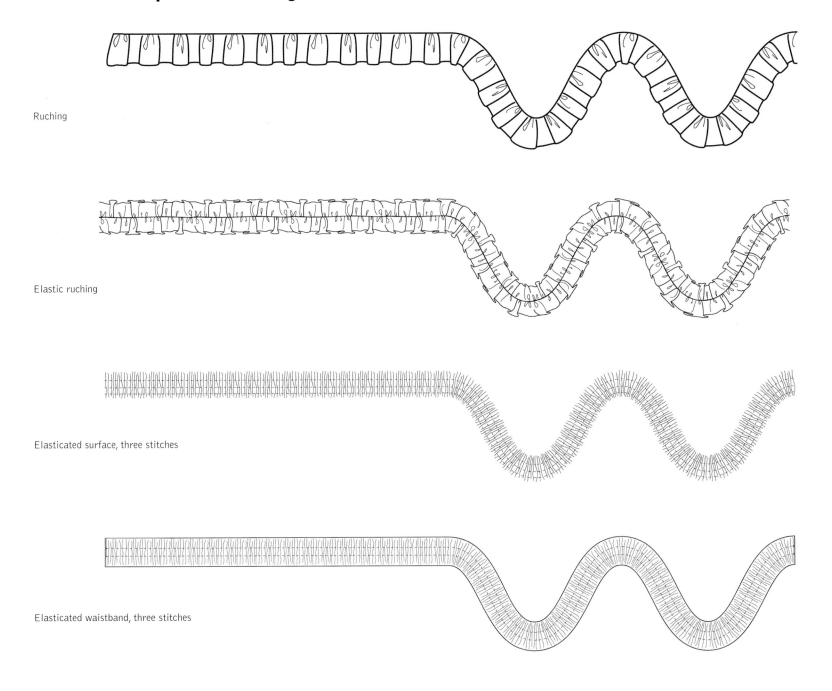

Ruching

Elastic ruching

Elasticated surface, three stitches

Elasticated waistband, three stitches

Tapes and lacing

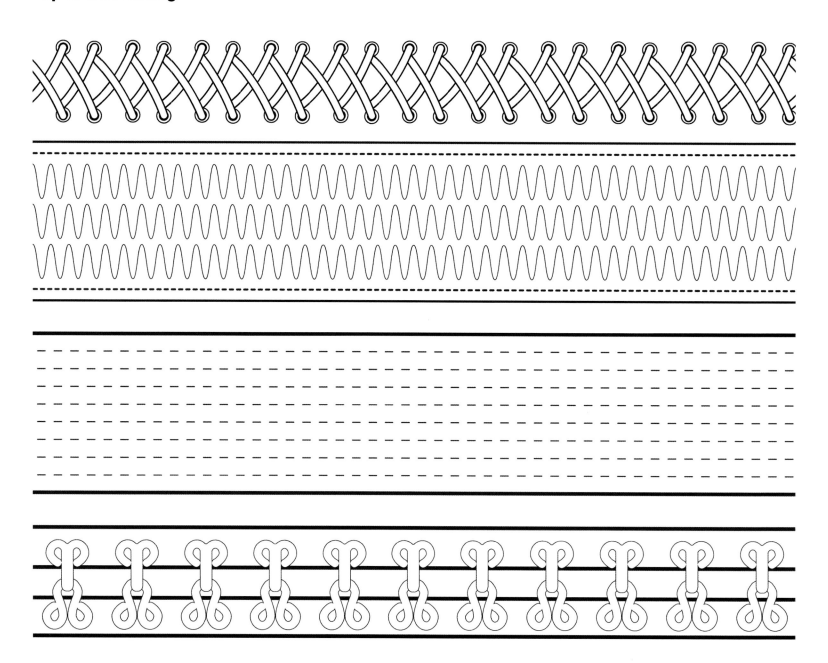

Pockets

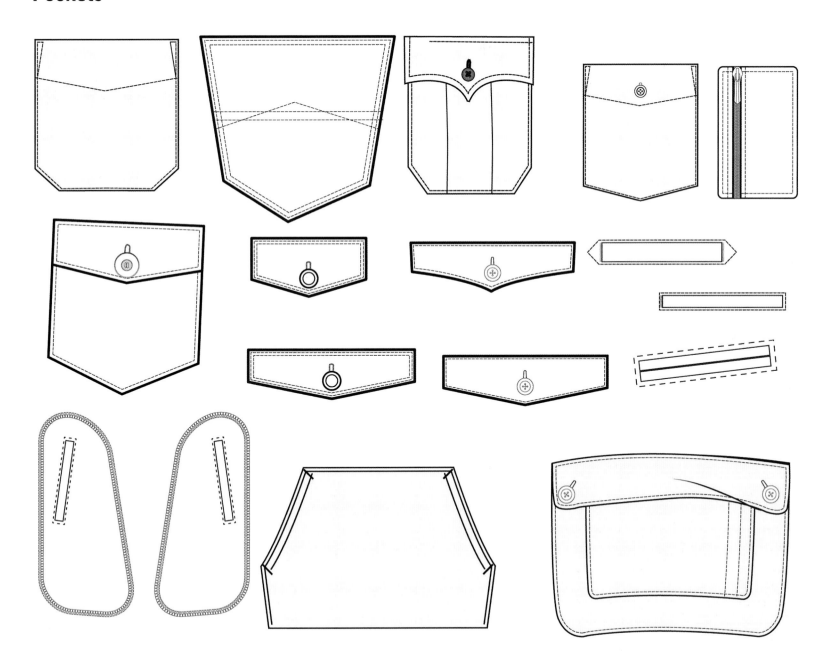

Collars

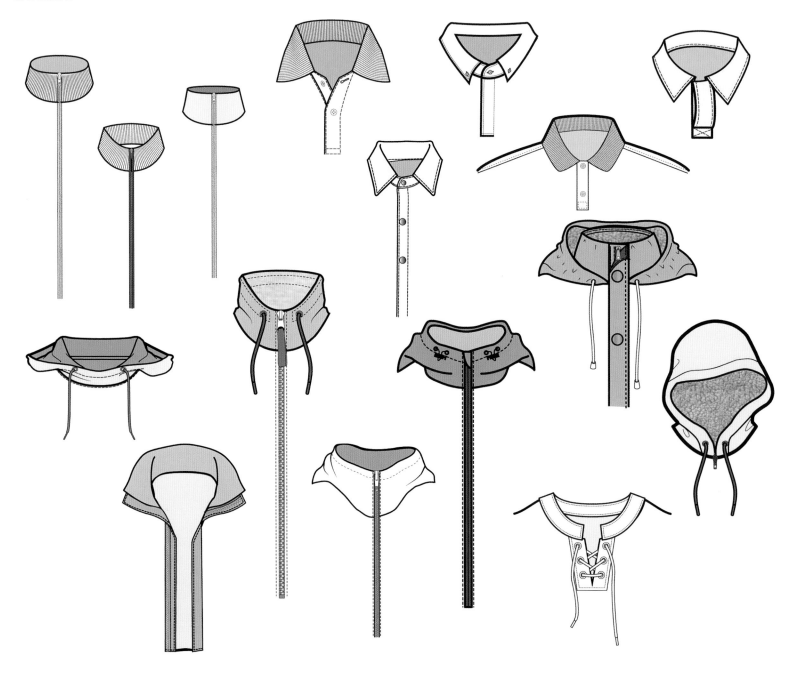

Trims

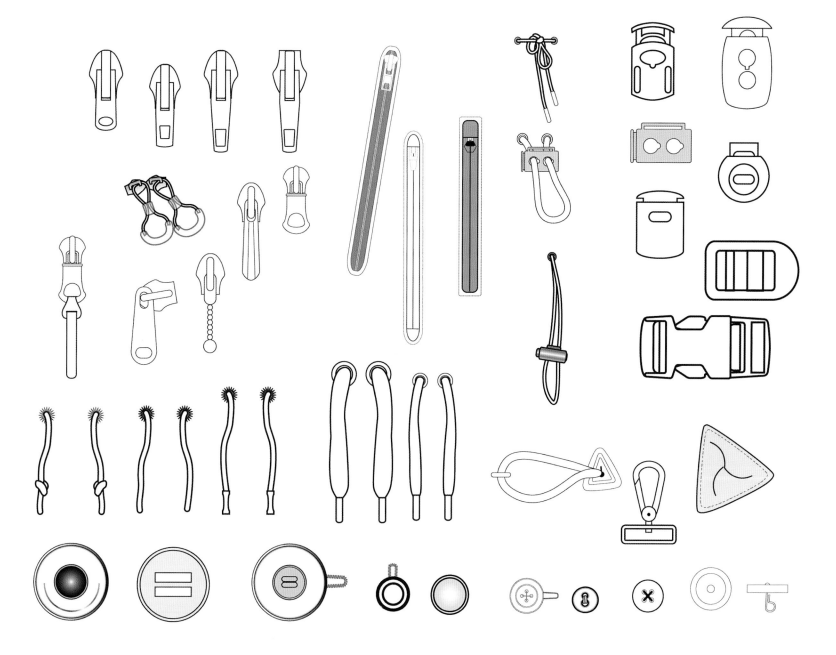

Glossary

Computer technical terms

GUI Graphical User Interface.

Bitmap A digital image made of pixels displayed in a grid. Each pixel contains singular colour information.

DPI (Dot Per Inch) The resolution of a bitmap image is defined by the DPI size. The higher the DPI size, the better the quality.

RAM (Random Access Memory) The live memory that your computer needs to temporarily store data for the Chip to access and process.

Vector Graphics Digital graphics based on mathematical equations, such as Bézier curves, made up of points and segments.

Non-destructive editing Digital-based editing that allows users to alter content without destroying the original material.

CCD chip (Charge-Coupled Device) A chip consisting of thousands of pixel elements which captures light and transfers the information to the camera processor.

Raster graphics Digital data representing a grid of pixels that represents an image.

EPS (Encapsulated PostScript) File format for importing and exporting PostScript files.

PostScript A page-description language commonly used in desktop-publishing.

PDF (Portable Document File) Adobe cross-platform file format.

.ttf (TrueType Font) File type of font suitcase encoding.

Operating system (OS) System under which a computer operates.

Adobe Illustrator technology

Bristle Brush Brushes used in both Illustrator and Photoshop that mimic real-life paintbrushes.

Bezier curves Editable curves used in computer graphics, invented by the French engineer Pierre Bézier.

Placed images in Illustrator, placed images are dynamically linked from their folder location into the document. If they are removed from the folder, the link is lost.

Preferences IIllustrator interface to fine-tune the way the application interacts with key features such as measurement units.

Embedded Images in Illustrator, embedded images are embedded into the document without any link. Embedded images do increase significantly the Illustrator document file size.

Bevel The non-perpendicular edge of a 3-D shape such as a rectangle.

Compound shapes At least two shapes compounded together to form a single object.

Vectorize To transform a Bitmap image into vector graphics.

Isolation Mode Mode in which grouped objects can be edited.

CMYK Colour standard for printing offset or digitally by outputting all colours from four base inks: cyan, magenta, yellow and black.

RGB Colour standard for on-screen viewing, outputting all colours from red, green and blue.

Segment Part of a line making a shape located between two anchor points.

Anchor Point Points onto which a segment anchors, either regular or with Bezier handles to create curved segments.

Pt (points) Units usually used to measure typeface sizes.

Fashion technical terms

CF (Centre Front) The centre of a garment's front side.

CB (centre back) The centre of a garment's back side.

AoP: (All-over Print) Print that covers the entire surface of a fabric roll.

Print tile A rectangle (or square) containing artwork that defines the area and boundaries of a repeat pattern.

SKU (Stock Keeping Units) refers to a colourway per style designed.

Pantone TPX or TC The Pantone colour company's code for their fashion and interior colour ranges. TPX indicates a colour that is printed on paper, while TC refers to dyed cotton fabric.

Merchandiser's boards Board depicting a serie of designs arranged to show how they will be merchandized in a store or online.

Line book A book or catalogue in which all the season collection's designs are depicted in vector flat drawings with article number and fabric information.

Hanger appeal Refers to how a garment will look when displayed on a hanger.

JIT (Just In Time) A fast fashion term for apparel being in-store just in time to match consumer demand at any given time.

Bartack Tight zigzag stitch to hold belt loops on trousers or secure a zipper in a fly front. It is also used to reinforce stress points, such as pocket-opening edges.

SKU sheets Design sheets onto which all SKUs are laid out.

Technical packs Design sheets onto which all technical information for a given design is displayed, to facilitate the development of the design into the actual garment.

Index